# IMAGES
## *of America*

# RAILROADS OF CHATTANOOGA

IMAGES
*of America*

# RAILROADS OF CHATTANOOGA

Alan A. Walker

ARCADIA

Copyright © by Alan A. Walker
ISBN 0-7385-1539-6

Published by Arcadia Publishing
an imprint of Tempus Publishing Inc.
Charleston SC, Chicago, Portsmouth NH, San Francisco

Printed in Great Britain

Library of Congress Catalog Card Number: 2003106046

For all general information contact Arcadia Publishing at:
Telephone 843-853-2070
Fax 843-853-0044
E-mail sales@arcadiapublishing.com
For customer service and orders:
Toll-Free 1-888-313-2665

Visit us on the internet at http://www.arcadiapublishing.com

# CONTENTS

# ACKNOWLEDGMENTS

This book would be far from complete without a section acknowledging my indebtedness to the following persons whose assistance has allowed this book to be written and the information therein properly recorded:

David H. Steinberg; Robert M. Soule, and Steven R. Freer, Tennessee Valley Railroad Museum; Glen Hill, Bridgeport Area Historical Association; Warren Stephens, Tennessee, Alabama, and Georgia (TAG) Railway Historical Society; Julie Dodson, Chattanooga Choo Choo; James Myers; Norfolk Southern Corporation; and Mr. and Mrs. William A. Varnell.

# INTRODUCTION

America in the early 1830s was on the move. Leading businessmen reasoned that the future of the young nation lay in the vast lands recently purchased from France by the late President Thomas Jefferson. The greatest challenge presented to these entrepreneurs was how to move the rich natural resources of this new land from the frontier to the cities where they were needed. Nowhere was this need more evident than on the frontier just west of the Appalachian Mountains. Up to this time, transportation and communication had been dependent on the location of settlements on navigable waterways. The lack of navigable waterways in this new territory presented the would-be entrepreneurs and settlers with their problem.

The key to the opening of the west was the development of the steam locomotive. The placement of the first steam locomotive in scheduled service was accomplished by the South Carolina Canal and Railroad Company on December 25, 1830. The development of the steam locomotive made long distance railroad operations practical for the first time. This was particularly important for Southern railroads. Southern railroads differed from their Northern counterparts in that they served distinctly different purposes. In most cases, the Northern railroads were intended to connect closely placed population centers. Southern railroads were built with the intent of connecting coastal and river ports with the Southern interior and the valuable crops located there, primarily cotton. Thus, Southern railroads were longer than their Northern counterparts, and they were built to a lesser quality.

Only 20 years after the introduction of the nation's first scheduled steam train, the first railroad arrived in the Tennessee Valley. The completion of connecting lines in 1854, 1859, and 1880 permanently established the growing river town of Chattanooga as a major transportation and manufacturing center. The importance of its transportation center made Chattanooga a primary target of the U.S. Army during the hostilities from 1861 to 1865. During the Reconstruction, the railroads brought Northern industrialists and their money to the shattered city. This development made Chattanooga one of the leading industrial cities in the South, earning it the title "The Dynamo of Dixie." In its peak in the 1920s, Chattanooga was served by nine railroads, one electric interurban line, and one trolley line. Chattanooga was the first Southern industrial city to have a direct rail link with a Northern industrial city, and in 1909, it was graced with one of the grandest railroad stations in the South.

In the years that followed, many changes occurred in Chattanooga. Beginning in the late 1950s, the area's manufacturing industries were at the peak of their influence, with more and more service industries employing the majority of area residents. By the 1970s, the number of independent railroads serving the area had dropped to two as a result of mergers, and intercity passenger trains in Chattanooga were a thing of the past. In this city that was losing its connection to the railroads, some Chattanooga railfans banded together to form a group aimed at preserving some remnant of railroading's Golden Age. The work of the group eventually led to the establishment of the Tennessee Valley Railroad Museum, now encompassing one of the oldest and most respected historic railroads in the nation.

# One

# CHATTANOOGA'S FIRST RAILROAD

## THE WESTERN AND ATLANTIC RAILROAD OF THE STATE OF GEORGIA

The story of Chattanooga's first railroad begins in the Georgia State Legislature with the introduction of the subject of a state railroad project in the November 1836 session. At that time three railroads had been chartered in central and southern Georgia. With the rapid development spreading towards the Midwest, it was reasoned that there should be some connection between the ports of coastal Georgia and the Mississippi Valley. The fact that major presentations on the subject were made in the House and Senate and that the governor included the matter of the state railroad project in his address to the legislature illustrate the degree with which the Georgians had become infused with the transportation idea. Action on this idea came shortly thereafter, and on December 21, 1836, an act creating the Western and Atlantic Railroad of the State of Georgia was passed by the legislature and signed by Governor William Schley.

The act passed on December 21, 1836 and was followed on December 28 by a joint resolution that was adopted and signed by the governor. The resolution directed the governor to ascertain the terms under which the State of Tennessee would permit the extension of the Western and Atlantic Railroad to a point on the Tennessee River in Tennessee. To that end, a second joint resolution was approved on November 30, 1837, requesting that the governor appoint and dispatch a special agent to the state legislature of Tennessee for the express purpose of negotiating on the behalf of the State of Georgia to authorize the extension of the Western and Atlantic Railroad to the Tennessee River, offering reciprocal privileges to any Tennessee railroad seeking a connection with the Western and Atlantic Railroad in Georgia. The special agent appointed by the newly elected governor, George R. Gilmer, was Gen. Daniel Newnan.

Newnan's efforts were successful in securing permission from the Tennesseans for the extension of the Western and Atlantic Railroad into Tennessee, as provided for in an act passed by the Tennessee legislature on January 24, 1838. The act only specified that the State of Georgia would be allowed a right of way from the state line to the Tennessee River and that the State of Georgia would be given the authority necessary to explore and survey land to determine the route of the line. All of the rights provided for in the act were conferred based on the condition that the State of Georgia would grant and concede similar rights to the State of Tennessee or her incorporated companies upon application.

With all the necessary legal rights secured, the only remaining task was the physical construction of the railroad. The act passed by the State of Tennessee did not affix the point on the Tennessee River to which the railroad would be built. Influential Chattanoogans, led by Col. James Whiteside and determined to attract the railroad to Chattanooga, mounted a sales pitch extolling the benefits of Chattanooga as a river port over the other river towns vying for the railroad. Once it was determined that the railroad would be built to Chattanooga, surveying of the line began in 1837 and the first grading of the railroad roadbed began in 1839, starting from Terminus (Atlanta, Georgia). Lack of consistent funding and the inability of the state to initially fund the project resulted in little construction progress until 1845, when the rail line was extended from Marthasville (formerly Terminus) to Marietta, a distance of 22 miles, in September of that year. Work on the railroad progressed steadily in the following three years, and by 1848 the line was completed to a point just below present-day Tunnel Hill, Georgia.

At this point, the line encountered Chetoogeta Mountain, which required the construction of a tunnel, as there was no way to build the line around it. The State of Georgia was very interested in opening the line for through passenger and freight service between Chattanooga and Atlanta. Rather than wait for the completion of the tunnel, the railroad crews constructed a portage road over the mountain. They then hauled sufficient supplies including rails, spikes, locomotives, and rolling stock around to the north side of the mountain and completed the line northward to Chattanooga. This work was completed in late November of 1849. The first train officially arrived in Chattanooga on December 1, 1849, and regular service commenced. However, until the completion of the railroad tunnel at Tunnel Hill on May 9, 1850, through passengers and freight had to be transported by livery service around Chetogetta Mountain.

The year 1851 saw the completion of Chattanooga's first railroad depot, built at the corner of Ninth and Market Streets. It was a small two-story brick structure that housed the passenger and freight facilities of the Western and Atlantic Railroad. The first floor had the passenger waiting room and freight offices, and the passenger department offices were on the second floor of the building. This building served as the passenger depot from 1851 to 1857 when passenger and freight traffic generated by the Western and Atlantic and connecting railroads had grown to such a level that a larger building was needed.

The immediate solution to the problem was the construction of the Car Shed, one block west of the original depot. It was built on a property at Ninth and Broad Streets, though the building actually came no closer than 100 feet to Broad Street. The reason for this was that at the time, trains were headed into the Car Shed. Rather than have the wood-burning locomotives foul the air in the Car Shed, the space between the building and Broad Street allowed the locomotives to pull the train into the shed and stop outside the other end of the building. The right of way would eventually extend from the railroad depot that would be constructed at the south end of town, proceed up the centerline of Mulberry Street, and terminate at the riverboat port at Ross's Landing at the north end of town. Although the railroad track would disappear by the end of the Civil War, its presence resulted in the change of the street's name to Railroad Avenue. Eventually the railroad connection was forgotten, and the name was changed once again to Broad Street.

The cost of the new Car Shed was divided among the three railroads then using the combined facilities, those companies being the Western and Atlantic Railroad, the Nashville and Chattanooga Railroad, and the Memphis and Charleston Railroad. A fourth company, the East Tennessee and Georgia Railroad, would make use of the Car Shed when the Chattanooga Branch from Cleveland to Chattanooga was opened to traffic in 1859. Construction on the 100-foot-by-304-foot building was begun in late 1857 and completed in mid-1858. Some railroad offices remained in the old depot, but the ticket offices were moved to the Car Shed and other passenger facilities were eventually moved into the Burns House, a small hotel built adjacent to the Car Shed in 1865. After the construction of the Burns House, no additional changes would be made to the property until 1881, when a new head building would be constructed at the foot of Broad Street.

As for the operations of the Western and Atlantic Railroad, there was nothing remarkable about them, other than the fact that from the time of its construction until 1870 it was a government-operated railroad. During the Civil War, all railroads serving Chattanooga were attacked by Union sympathizers, and the Western and Atlantic was the victim of the boldest attack. On the morning of April 12, 1862, the Atlanta to Chattanooga morning express was hijacked at its breakfast stop at Big Shanty, Georgia, by the U.S. Army spy James J. Andrews and his raiding party of U.S. soldiers. Their intent was to burn the railroad bridges between Atlanta and Chattanooga to prevent the Confederate Army from reinforcing the troops in Chattanooga when the U.S. Army advanced on that city. But for the decision by Andrews to delay the raid by one day, a heavy rain, and the dogged pursuit of the stolen train by its conductor, William A. Fuller, the raid would have been a success. The raiders failed to accomplish their task and were all captured. Andrews and several of the men were convicted of espionage and hanged, but the remainder of the men either escaped from prison and made their way back to friendly lines or were traded as prisoners of war.

The State of Georgia continued to operate the Western and Atlantic Railroad until September 1864. Then, as the Confederates were pushed out of the area, the U.S. Military Railroad took over the line and operated it until the end of September 1865. Like most Southern railroads at the end of the war, the Western and Atlantic was in very poor condition, and it had to be entirely rebuilt over a period of two years. The railroad continued as a state operation until December 27, 1870, when former Gov. Joseph E. Brown and company leased it for a period of 20 years.

The lease of the Western and Atlantic Railroad of the State of Georgia was executed under authority granted to the governor by the state legislature in an act approved on October 24, 1870. Part of the order stated that "no Railroad or Express Company, or any combination of them, shall in any event become the lessees, but they may become sureties on the Bonds of the lessees." This stipulation was much regretted by the State when the lease came to its end in 1890. While the railroad was responsibly managed from a fiscal standpoint, the only ones to profit from the railroad in the end were former Governor Brown and his investors. The only significant improvement made to the property that the State would benefit from was the completion of a new head building in Chattanooga in 1882. At that time, the railroad facility was named Union Depot.

The new head building was erected on the site of the Burns House, and the railroad tracks at the north end of the Car Shed removed. The building, opened on July 1, 1882, was the first large public building in Chattanooga to feature electric lighting, and it had a dining room on the main floor along with the waiting room, gentleman's smoking room, and a separate ladies' waiting room. The second floor was reserved for the passenger department. All of the floors in the depot were wood planking, with the exception of the entry hall, which had a mosaic tile floor. Around 1900, the space below the main floor was filled in and a floor of Georgia marble was installed.

In the lease agreement of 1870, there were some additional clauses that created trouble for the State and subsequent lessees. One clause stipulated that only the quantity of rolling stock and locomotives originally leased to the Western and Atlantic Railroad had to be turned back in at the end of the lease. New locomotives that had been purchased by Brown's Western and Atlantic Railroad and placed in service alongside the original locomotives were sold to other railroads instead of being turned in. Only a handful of the locomotives returned were fit for service. The road's few passenger cars were fit for service, but the company's 500 freight cars were not. The freight cars were all scrapped by the new lessee in 1890.

The state had learned from its mistakes in the first 20-year lease, which led to additional requirements for subsequent lessees of the state railroad. The act authorizing the governor to seek bids for a lessee in 1890 stipulated that advertisements would be placed in leading newspapers seeking railroad companies to bid for the lease. The Nashville, Chattanooga and St. Louis Railway won the lease of the Western and Atlantic Railroad in competitive bidding in

1890, outbidding the Richmond and Danville Railroad by one dollar. As it turned out, the lease was renewed by the Nashville, Chattanooga and St. Louis Railway and its successor companies, the Louisville and Nashville Railroad and CSX Transportation, up to the present.

As for Union Depot, it continued to serve Chattanooga's railroads uneventfully until 1905, when the first of two notable events occurred. Most of the marble floor was destroyed in a freak accident on April 5, 1905. During the lunch hour, a Nashville, Chattanooga and St. Louis Railway locomotive was being serviced just outside the Car Shed on the center track. It had arrived in the late morning and was being prepared by a wiper for its next run when it "got away" from the wiper and started towards the Car Shed, gaining speed with every turn of its large driving wheels. Unable to stop the locomotive, the wiper jumped off. A railroad policeman who saw the wiper jump from the locomotive ran into the head building to evacuate it, which was done in record time according to the local papers. The locomotive ran off the end of the track in the Car Shed at approximately 20 miles an hour, destroying a wooden staircase, the double walnut doors that separated the head building from the Car Shed, and about 60 feet of the Georgia marble flooring. Damage to the locomotive was limited to the pilot, headlamp, and whistle rod, which was broken by the top of the door frame, causing the whistle to blow until railroad employees could shut off its steam line. Only one employee was seriously injured, and within a few hours the errant locomotive was removed from the head building.

The second event was the fire of January 9, 1911, that burned almost 300 feet of the south end of the Car Shed. The shed was rebuilt and extended an additional 120 feet, bringing it to a total length of 424 feet. In 1926, the City of Chattanooga condemned portions of the Union Depot property for the purpose of extending Broad Street south towards Lookout Mountain. This resulted in the removal of all but 124 feet at the north end of the Car Shed in 1926. In place of the old shed, three modern butterfly sheds capable of handling trains up to 14 coaches long were installed. Union Depot remained in this configuration until its demise in late 1972, following discontinuance of the Louisville and Nashville Railroad's *Georgian* on May 1, 1971— the last passenger train to serve Chattanooga. Today, the site is occupied by the Tennessee-American Water Company offices, the Krystal Building, the Chattanooga-Hamilton County Bicentennial Library, and the Tennessee Valley Authority offices. Hardly anything remains to remind the passerby that a great passenger station once stood there. The original Western and Atlantic depot built in 1851 survived until 1959, when the widening of Ninth Street brought about its demise.

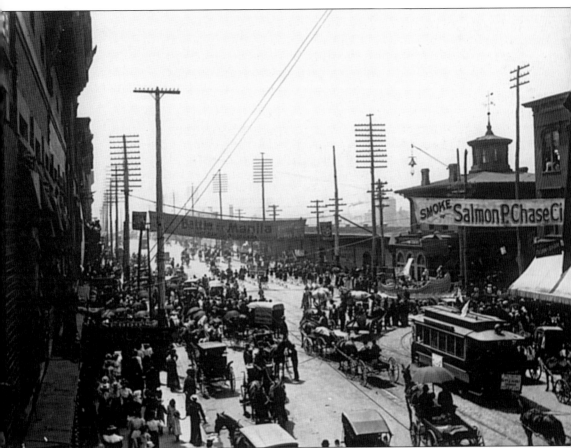

It's time for the May Festival Parade in downtown Chattanooga. This view of the 1900 May Festival Parade catches the parade turning north on Market Street as a Chattanooga Electric Railway streetcar passes in front of the old Western and Atlantic depot, built in 1851. It was replaced as the main passenger facility in 1881, when the new head building at Union Depot was constructed. A victim of "progress," it survived until the widening of Ninth Street in 1959, ending its days as the Chattanooga Steak House. (Courtesy David H. Steinberg.)

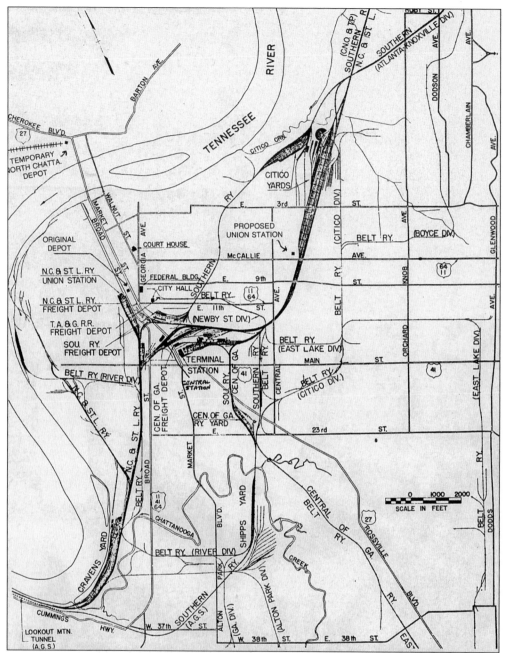

This 1930s vintage map provides an extensive overview of the railroad facilities in the downtown Chattanooga area. Development has led to a major reconfiguration of Chattanooga's railroad landscape. Much of Craven's Yard, the Belt Railway, and virtually all of the lines north of Main Street and west of Central Avenue have been abandoned. (Courtesy of David H. Steinberg.)

One of the earliest locomotives operated by the Western and Atlantic Railroad was the *Yonah*. Built by Rogers, Ketchum and Grovesnor of Patterson, New Jersey, in 1848, it was the third American-type locomotive bought by the road. Most likely it was a locomotive like the *Yonah* that pulled the first train into Chattanooga on December 1, 1849. Being equipped with a kettle-type boiler, the locomotive was technologically obsolete by 1860 and was scrapped in the late 1870s after serving as the shop boiler at the railroad's Atlanta shops. The *Yonah's* moment in the sun came on April 12, 1862, when she was commandeered by Conductor William A. Fuller and became the initial locomotive involved in the pursuit of James J. Andrews and his raiders. (Courtesy Leo Myers Collection-James Myers.)

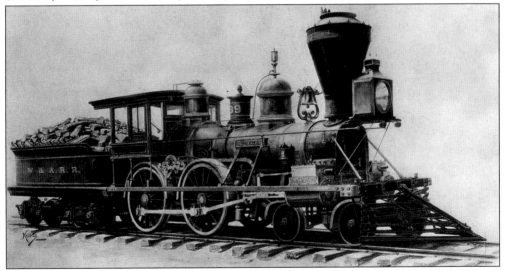

One of the first modern American-type locomotives to operate on the Western and Atlantic Railroad was the *General*. She was built in late 1855 by Rogers, Ketchum and Grovesnor and delivered to the railroad in December of that year. Rebuilt in 1865 and heavily modified in the 1870s, she was restored to her immediate post-war appearance by the Nashville, Chattanooga and St. Louis Railway in 1891. This drawing made by Wilbur Kurtz in 1912 shows the locomotive as it would have appeared when delivered. (Courtesy Leo Myers Collection–Alan Walker.)

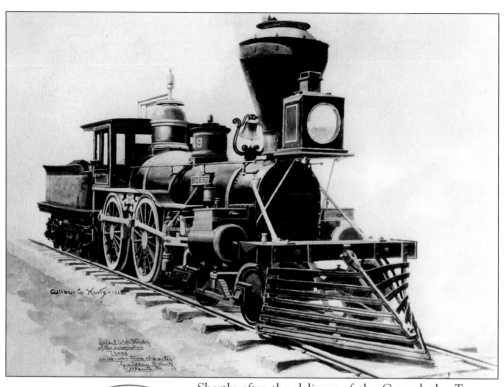

Shortly after the delivery of the *General*, the *Texas*, a similar machine, was delivered by Danforth and Cooke of Patterson, New Jersey, in early 1856. On April 12, 1862, the *Texas* was pulling a southbound express freight when it passed the *General* near Adairsville, Georgia. Just north of Kingston, her train was stopped by Conductor Fuller and engaged in the pursuit of Andrews Raiders. This 1912 drawing made by Wilbur Kurtz shows the locomotive as delivered in 1856. Notice that there are differences between the two locomotives, even though they were built only months apart. (Courtesy Leo Myers Collection–Alan Walker.)

James J. Andrews (1829–1862), a federal spy and resident of Flemingsburg, Kentucky, was the leader of the raiding party that took the *General* while the passengers and crew took breakfast at the Lacy Hotel in Big Shanty (Kennesaw), Georgia. Captured near Ringgold, Georgia, after abandoning the locomotive, he was tried and convicted as a spy. He was executed in Atlanta, Georgia, on June 7, 1862. Andrews and several other raiders executed now rest in the National Cemetery at Chattanooga, Tennessee. (Courtesy Leo Myers Collection–Alan Walker.)

16

William A. Fuller was the conductor of the morning Atlanta to Chattanooga express on April 12, 1862. While seated at breakfast at Lacy's Hotel, his train was taken by men unknown to him. It was his dogged pursuit of the "engine thieves" that prevented James Andrews from accomplishing his goals. Conductor Fuller's railroad career ended in 1869 when the Democrats lost the state elections. Fuller became a successful businessman and prominent citizen of Atlanta, where he resided until his death on December 28, 1905. (Courtesy Leo Myers Collection–Alan Walker.)

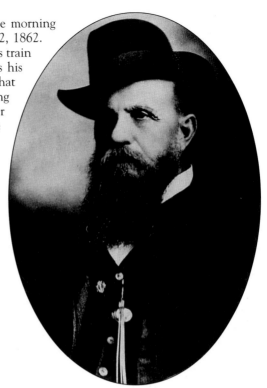

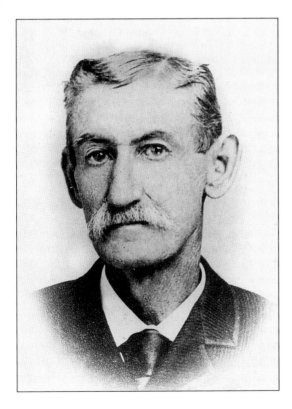

In the early days, railroads assigned locomotives to individual engineers. Engineer Jeff Cain (pictured here) pursued the *General* along with Conductor Fuller and Machinery Superintendent Anthony Murphy. Health conditions forced him to drop from the pursuit above Kingston when the Rome Railroad's *William R. Smith* was stopped by a removed rail. (Courtesy Leo Myers Collection–Alan Walker.)

17

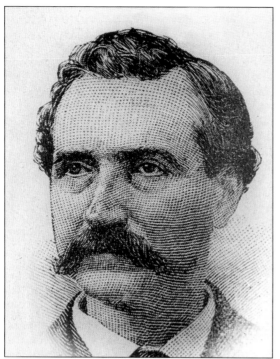

Employed as the superintendent of machinery for the railroad at the time of the raid, Anthony Murphy was traveling on the morning train to Chattanooga with the purpose of inspecting a locomotive that had been reported damaged. Following Conductor Fuller, he inspected the *General* once it was recaptured and found that with the exception of one burned bearing, the locomotive was in good condition considering what it had been through. It was towed back to Ringgold and later moved to Dalton by Superintendent Murphy. (Courtesy Leo Myers Collection–Alan Walker.)

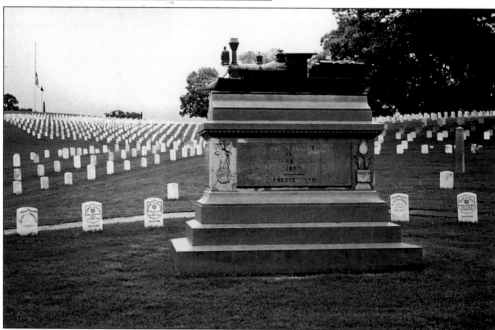

This monument, located in the National Cemetery at Chattanooga, is Ohio's tribute to the Andrews Raiders, all of whom were volunteers from the 2nd, 21st, and 33rd Ohio Volunteer Infantry except William Campbell (a civilian from Salineville, Ohio) and the leader, James J. Andrews (a civilian from Flemingsburg, Kentucky). The monument, dedicated in 1891, stands in front of a semi-circle, formed by the graves of the eight raiders executed in 1862. Andrews's grave is at far left. (From the author's collection.)

Just south of the Oostanaula River railroad bridge, near Calhoun, Georgia, Conductor Fuller and his party first sighted the *General*. The close proximity of pursuers prevented the raiders from damaging this bridge. Typical of railroad bridges of the day, many of those found on the Western and Atlantic Railroad were covered bridges. (Courtesy Leo Myers Collection–Alan Walker.)

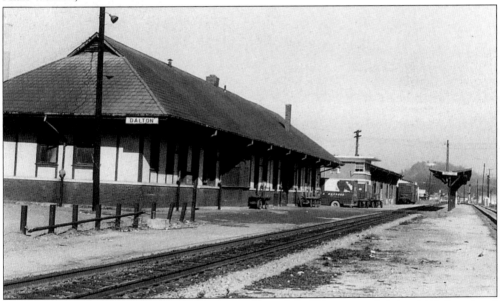

In 1847 Dalton, Georgia, was the connection point of the Western and Atlantic Railroad and the East Tennessee and Georgia Railroad, which later became the Southern Railway. In this 1950s view, the Western and Atlantic Railroad main line is at left and the Southern Railway main line is to the right of the butterfly platform. This particular building was constructed in the 1880s or 1890s. (Courtesy David H. Steinberg.)

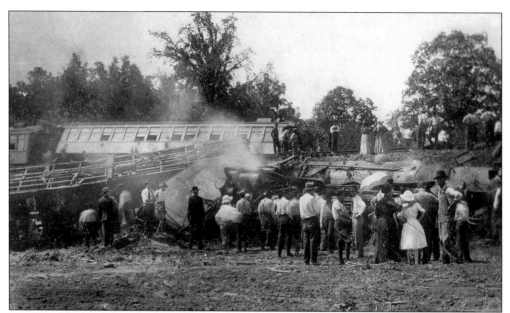

On the evening of June 12, 1912, Extra No. 179, a passenger train carrying a Knights of Pythias excursion from Calhoun, Georgia, to the Chickamauga and Chattanooga National Military Park derailed two miles above Dalton. Two railroad employees and one passenger were killed in the derailment, which was attributed to excessive speed. (Courtesy Leo Myers Collection–Alan Walker.)

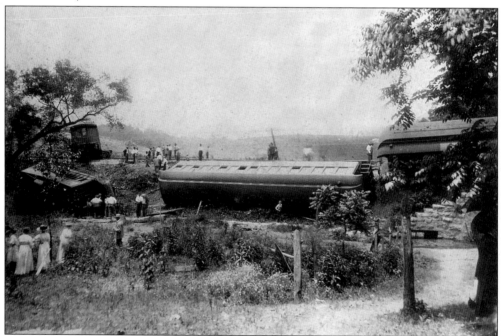

This photograph is a second view of the wreck of Extra No. 179 taken from the opposite side of the track. The employees killed were the locomotive fireman and a railroad section man who was waiting for the train to pass. The passenger killed was in the baggage car when the train derailed. (Courtesy Leo Myers Collection–Alan Walker.)

William Whitten, the Tunnel Hill station agent, was hired by the Western and Atlantic Railroad in 1852 or 1853. He is believed to have been the first railroad agent at Tunnel Hill, Georgia. A Southern sympathizer, he was arrested by Federal authorities during the Civil War and imprisoned. Following the war, he was pardoned and returned to Tunnel Hill, where he remained as station agent from 1866 to 1872. Restoration of full citizenship was important, as the railroad was operated by the State of Georgia until 1870. (Courtesy Leo Myers Collection–Alan Walker.)

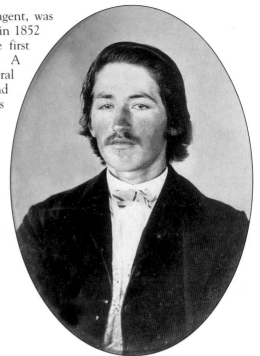

This turn of the century view shows the depot and tunnel at Tunnel Hill, Georgia. The tunnel was completed in May 1850 and it is believed that the depot was completed in 1852. Like many of the other depots built by the Western and Atlantic Railroad, the Tunnel Hill depot was a stone building. This was uncommon for a rural depot in that day and time. (Courtesy Leo Myers Collection–Alan Walker.)

This is the Tunnel Hill railroad hotel, c. 1885. During the very early days of the road's operation, there was no through train service between Atlanta and Chattanooga. In order to get the road open for business as quickly as possible, the company hauled locomotives, cars, and supplies around Chetoogeta Mountain so that operations could be commenced while the tunnel was still under construction. Passengers traveling from Atlanta to Chattanooga would transfer to a stagecoach for the trip around the mountain until the tunnel was completed on May 9, 1850. It is possible that the railroad provided hotel facilities at Tunnel Hill that may have doubled as waiting facilities until the depot was completed. (Courtesy Leo Myers Collection–Alan Walker.)

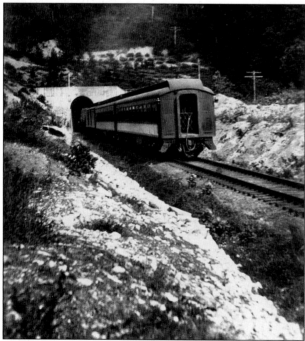

In the 1920s, it was determined that the needs of the railroad at Tunnel Hill would be best addressed through the construction of a new tunnel to replace the aging 1850 bore. On December 28, 1928, the railroad opened a new bore that paralleled the old tunnel. Here, a southbound passenger train is seen entering the north portal of the new tunnel. (Courtesy Leo Myers Collection–Alan Walker.)

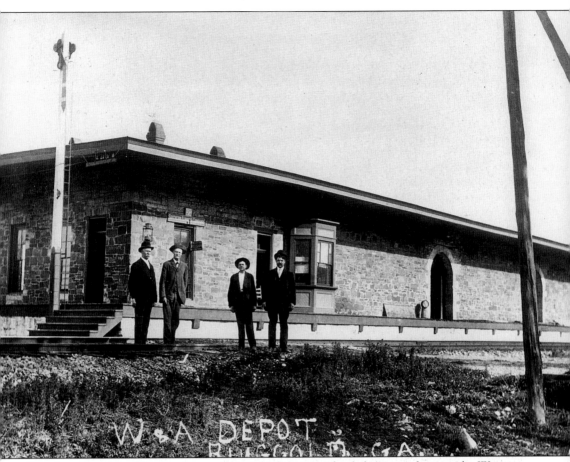

The depot at Ringgold was a stone structure built in a similar fashion to others on the Western and Atlantic Railroad. The depot, constructed in 1849, had the baggage area at the north end of the building while the agent's office and waiting area were located at the south end of the building. This photograph shows the depot as it appeared in the 1890s. The men in the photograph are not identified but may be railroad employees. (Courtesy Leo Myers Collection– Alan Walker.)

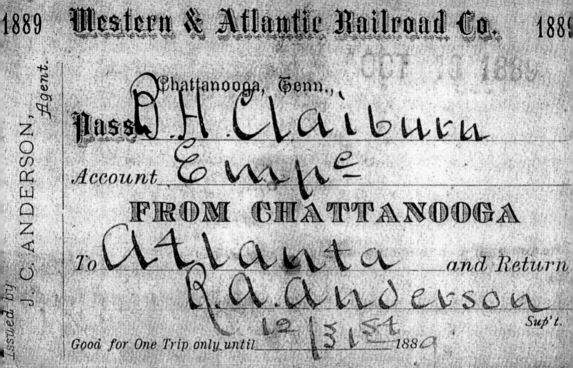

This pass was issued to B.H. Clairburn, an employee of the Western and Atlantic Railroad. Issuance of passes to employees for purposes of railroad business was very common in the days of passenger trains. This pass was issued by the railroad in the last year that the line was operated by the Western and Atlantic Railroad Company, a business concern headed by former Georgia governor Joseph E. Brown and other businessmen. (Courtesy Leo Myers Collection–Alan Walker.)

# Two

# MORE RAILROAD CONSTRUCTION

## THE NASHVILLE AND CHATTANOOGA RAILROAD

While the Georgians were the first to begin construction of a major railroad into the Southern interior, they were by no means the only early Southerners dreaming of railroad connections between ports and inland towns. On December 11, 1845, the Nashville and Chattanooga Railroad was chartered to construct a railroad line from Nashville over the Cumberland Mountains to Chattanooga and a connection with the Western and Atlantic Railroad, which was already under construction. The chartering of this railroad was only accomplished after vigorous state-wide campaigning by the project's two main supporters, Dr. James Overton of Nashville and state legislator Col. James A. Whiteside of Chattanooga. The actual organization of the company and construction of the line did not begin until 1848.

Construction of the railroad was quite a challenge, facing three major obstacles between Nashville and Chattanooga: Cumberland Mountain, the Tennessee River, and Running Water Creek. It was recognized early on that the tunnel at Cumberland Mountain would require a lengthy construction project. Rather than building the railroad to Cowan and waiting for the completion of the tunnel, workmen were immediately dispatched to the tunnel site. Work on the tunnel commenced in late 1848, and the 2,228-foot-long tunnel was completed on February 22, 1852, prior to the arrival of the grading or track-laying gangs at the foot of the mountain. The line then crossed the state line into Alabama, passing through the town of Stevenson and crossing the Tennessee River at Bridgeport with a bridge crossing over Long Island (Bridgeport Island). The bridge as completed crossed the West Channel with a fixed bridge and the East Channel (navigation channel) with a swing-type drawbridge, and there was a carriageway on the lower deck. Eventually the portion of the bridge constructed on the island was replaced with an earthen fill. East of the Tennessee River bridge, the line followed the south bank of the Tennessee River, crossing the ravine at Running Water Creek, near Whitwell, Tennessee, on a trestle 780 feet long and 116 feet high. It then dipped down into Georgia, crossing back into Tennessee at Wauhatchie and following the Tennessee River around the foot of Lookout Mountain into Chattanooga. Full operation of the line between Nashville and Chattanooga began on February 11, 1854.

From 1854 to 1858, the Nashville and Chattanooga was the only railroad connection Chattanooga had with any city to the west. On June 3, 1858, the Nashville and Chattanooga Railroad signed a contract with the Memphis and Charleston Railroad (later part of the East Tennessee, Virginia and Georgia Railroad). The agreement allowed the Memphis and Charleston line to connect with the Nashville and Chattanooga line at Stevenson, Alabama, and to operate their trains over the Nashville and Chattanooga line between Stevenson and

Chattanooga, under the terms of a 20-year lease of joint use of track. One particular stipulation was that the Memphis and Charleston line would not provide any local passenger or freight services between Stevenson and Chattanooga, except whatever services were necessary to fulfill their mail contracts with the Railway Mail Service of the U.S. Post Office. A similar lease agreement was executed between the Nashville and Chattanooga line and the Wills Valley Railroad, chartered in 1853 to construct a line from Wauhatchie, Tennessee, to Meridian, Mississippi. Actual construction of the line did not commence until sometime in 1860, and only 14 miles of track from Wauhatchie to Trenton, Georgia, had been completed at the outbreak of the Civil War. Completion of the line would not occur until 1871.

Additional changes were in the future of the Nashville and Chattanooga Railroad. On January 27, 1873, the name of the Nashville and Chattanooga Railroad was changed to the Nashville, Chattanooga and St. Louis Railway, which reflected the road's ultimate goal to connect with the Gateway City. This never happened, due in part to the acquisition of the Nashville, Chattanooga and St. Louis Railway by the Louisville and Nashville Railroad in 1880. In 1879, the wooden bridge spans at Bridgeport Island were replaced with a steel bridge and the swing-type drawbridge was replaced with a new span built in 1890 in Louisville, Kentucky. This drawbridge was replaced 91 years later with a lift bridge, removed from a Louisville and Nashville line at Danville, Tennessee. Although the Louisville and Nashville Railroad was the majority stockholder, the Nashville, Chattanooga and St. Louis Railway was allowed to operate autonomously until 1957, when it was merged into the Louisville and Nashville Railroad.

Shortly after the merger of the Nashville, Chattanooga and St. Louis Railway and the Louisville and Nashville Railroad was completed, major changes were made that directly affected the railroad in Chattanooga. In March 1959, the Louisville and Nashville Railroad announced that it was starting construction on an $18 million rail yard at Wauhatchie, Tennessee, just west of Chattanooga. This was the second phase of Plan N, the Chattanooga rail relocation project. The yard opened on April 12, 1961, replacing Craven's Yard, which was built in 1900 and by that time was located on prime industrial real estate. This phase of Plan N also called for the relocation of the main lines of the old Western and Atlantic Railroad south of the downtown section of Chattanooga. The work was accomplished by constructing the line along the banks of Chattanooga Creek, carrying Broad Street over the line on a new overpass and paralleling the Southern Railway lines from Twenty-third Street to Main Street. The Broad Street overpass and the connection with the Southern were completed in 1967. The last part of the relocation plan required work that would affect the Southern and was not completed until 1972. The Louisville and Nashville Railroad, itself a subsidiary of the Atlantic Coast Line, became part of the Seaboard Coast Line in the 1970s and eventually part of CSX Transportation.

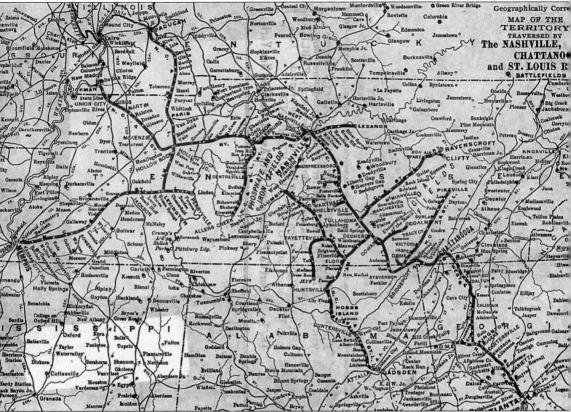

The first railroads to reach Chattanooga were the Western and Atlantic Railroad of the State of Georgia and the Nashville and Chattanooga Railroad, later renamed the Nashville, Chattanooga and St. Louis Railway. This map shows the system of the Nashville, Chattanooga and St. Louis Railway following the lease of the Western and Atlantic Railroad in 1890. (From the author's collection.)

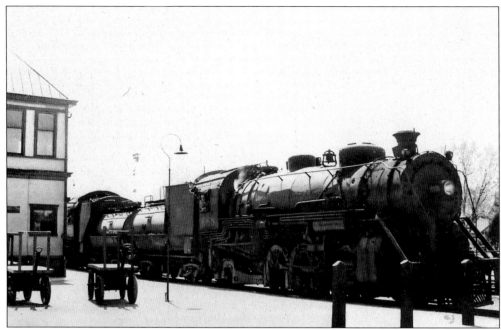

Since the opening of the Nashville and Chattanooga Railroad in 1854, pusher locomotives were employed to assist trains crossing Cumberland Mountain. This late-1940s photograph catches two L1-class locomotives at Cowan, Tennessee, awaiting the next train. The L-class locomotives were used in tandem, replacing the three M1-class Mallet-type locomotives that served as pusher locomotives from 1915 to 1945. (Courtesy David H. Steinberg.)

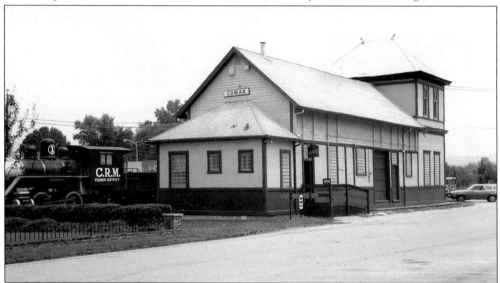

Like many small-town railroad stations, the depot at Cowan, Tennessee, was given a second life as a local railroad museum. Originally the depot stood on the opposite side of the main line and the platform straddled the main line. One of the conditions set by the railroad when the depot was given to the town in 1980 was that the depot had to be moved back a safe distance from the main line. To accomplish this, the depot had to be jacked up, moved across the tracks, and rotated 180 degrees. (Courtesy Tennessee Valley Railroad Museum.)

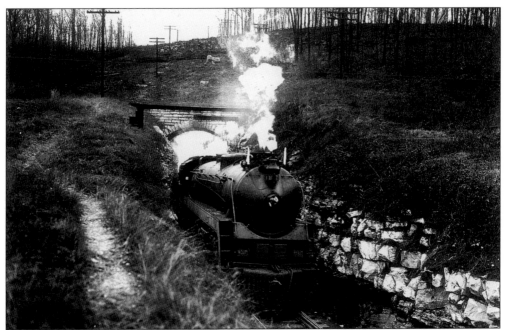

The first of the major obstacles faced by the Nashville and Chattanooga Railroad was Cumberland Mountain. On February 22, 1852, the 2,228-foot Cumberland Mountain tunnel was completed. This late 1940s photograph by company photographer H.C. Hill Sr. finds a northbound train powered by a J3-class Yellowjacket exiting the north end of the tunnel, passing under the stone bridge of the Tracy City Branch. The Tracy City Branch was abandoned in 1986. (Courtesy Tennessee Valley Railroad Museum.)

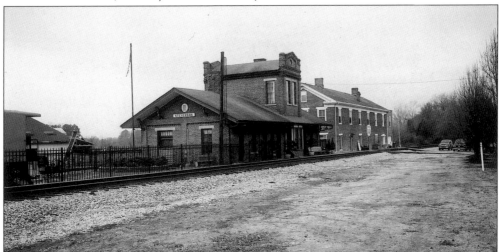

Stevenson, Alabama, was one of the major junctions on the Nashville and Chattanooga Railroad. In 1857, the Memphis and Charleston Railroad connected with the Nashville and Chattanooga Railroad, forming the last link in the Memphis and Charleston's line between Memphis and Chattanooga. The depot at Stevenson and the railroad hotel west of it date to 1872. The track nearest the camera is the Nashville, Chattanooga and St. Louis Railway main line. The Southern Railway main line (former Memphis and Charleston line) is on the far side of the depot. (From the author's collection.)

This undated view shows the original Nashville and Chattanooga freight depot at Bridgeport, Alabama, prior to 1917. That building was replaced by 1917, when a new passenger station was erected at Bridgeport. (Courtesy Bridgeport Area Historical Association.)

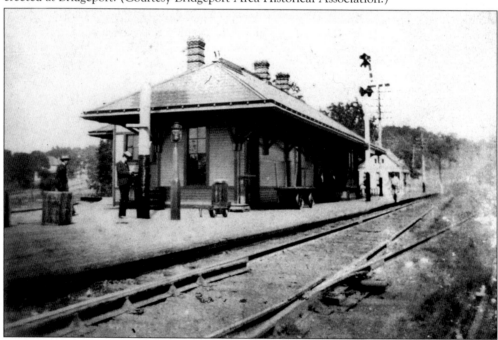

This depot was built at Bridgeport, Alabama, in 1889. Taken in 1906 by Bradley Crawford Jones Jr., this photograph looks east, showing the division superintendent's office for the Sequatchie Valley branch line. The office, also built in 1889, was removed in 1916 to make space for a new freight platform for the new station. The original depot survived as storage and shop space until the mid-1960s. The present yard office now stands on the site of the 1889 depot. (Courtesy Bridgeport Area Historical Association.)

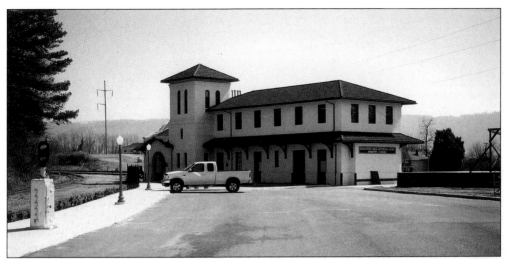

This Spanish Mission–style depot was built at Bridgeport in 1917, replacing the older 1889 structure. The depot had the agent's office and dual waiting rooms on the main floor: one for white passengers at the east end and one for "colored" passengers at the other. The second floor housed offices and a bunk facility for railroad employees. The depot is now home to the Bridgeport Area Historical Association and its museum, which opened in November 2002. (From the author's collection.)

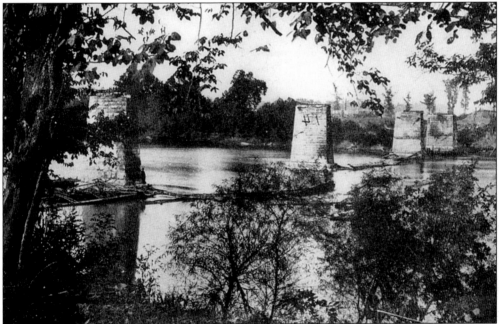

This view shows the remains of the fixed bridge at Bridgeport Island, just east of the railroad depot. During the advance of the U.S. Army in April 1862, the Confederate Army retreated towards Chattanooga after being driven from Stevenson and Bridgeport. As they retreated, they attempted to destroy both portions of the bridge at Bridgeport Island but only succeeded in destroying the draw span on the east side of the island. The fixed bridge on the west side was destroyed by U.S. Army forces after a change in battle plans but was rebuilt by that September. (Library of Congress photo courtesy Bridgeport Area Historical Association.)

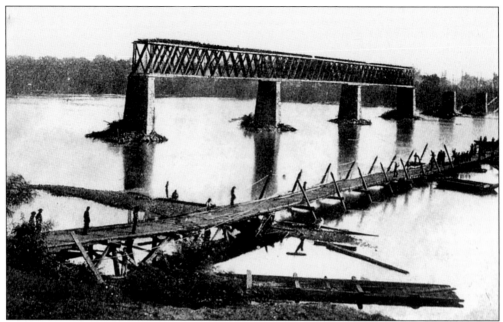

This view shows the ruins of the fixed bridge at Bridgeport Island in the fall of 1863, following its burning by the Confederate Army on orders of Gen. Braxton Bragg on July 5 of that year. Notice the pontoon bridge under construction in the foreground, as well as the design of the bridge spans. Like many railroad bridges of the day, this bridge had a lower deck that served as a carriageway, allowing horse-drawn wagons to use the bridge. (Library of Congress photo courtesy Bridgeport Area Historical Association.)

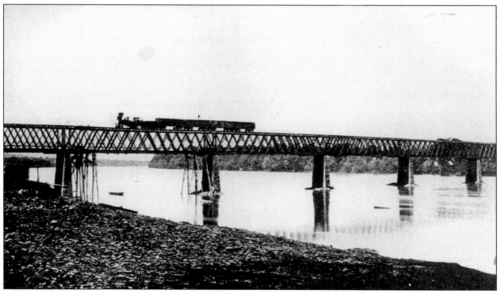

Following the second burning of the bridges at Bridgeport Island, repairs were again made and the line placed back in operation. By this time, the operation of the line had been handed over to the U.S. Military Railroad, which would operate it until the end of the war. This view taken after repairs in 1863 shows a U.S. Military Railroad train heading north towards Nashville. (Library of Congress photo courtesy Bridgeport Area Historical Association.)

This photograph taken by Bradley Crawford Jones Jr. in 1906 caught a westbound Southern Railway train as it crossed the fixed bridge at Bridgeport Island. In 1890, major repairs made to the bridge included replacement of the wooden bridge spans with steel trusses. Track usage agreements between the Nashville and Chattanooga and the Southern Railway allowed the latter to use the former's track between Chattanooga and Stevenson. (Courtesy Bridgeport Area Historical Association.)

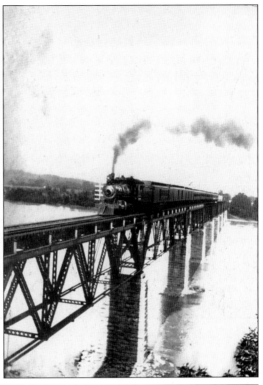

This view shows the new railroad bridge at Bridgeport Island. It was completed in the late 1990s and replaced the Civil War–era structure. In the distance, the towers of the lift bridge over the east channel can be seen. (From the author's collection.)

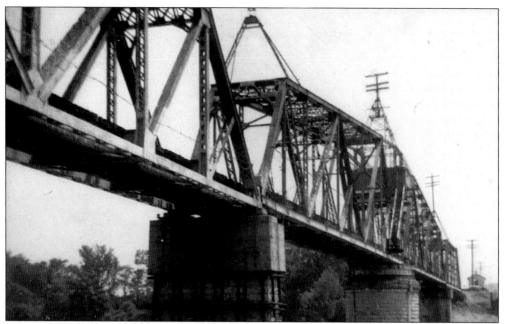

This draw span carried the railroad line over the navigation channel on the east side of Bridgeport Island and was installed in 1890, replacing the earlier wooden draw span. To allow river traffic to pass, it rotated 90 degrees. This bridge was replaced on October 26, 1981, with a 300-foot-long lift span due to its age and deteriorating mechanical condition. (Courtesy Bridgeport Area Historical Association.)

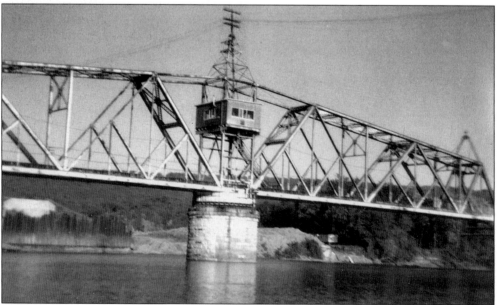

This second view of the rotating draw span at Bridgeport Island shows the span opened to allow river traffic to pass. In the background, the ground is being prepared for the new lift bridge. To prevent closure of the line during the bridge replacement, the lift bridge was built just upstream of the rotating bridge, allowing it to carry train traffic until the new bridge was completed. (Courtesy Bridgeport Area Historical Association.)

This 1984 photograph has caught the new lift bridge at Bridgeport open to allow river traffic to pass. The bridge was built in 1930 and originally installed on the Louisville and Nashville Railroad at Danville, Tennessee. That line was abandoned about the time that the railroad determined that a bridge replacement was required at Bridgeport. Rather than have a whole new bridge built, the railroad dismantled the lift span at Danville and floated it on a barge to Bridgeport, where it was reassembled. (Courtesy Steven R. Freer.)

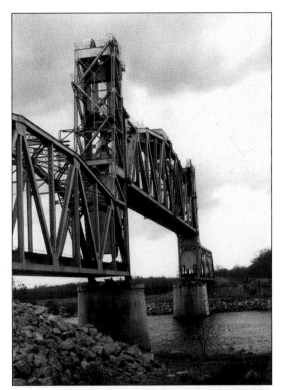

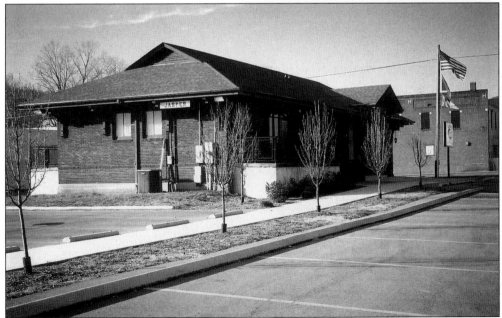

Railroad service was first extended to Jasper, Tennessee, in 1867 by the Nashville, Chattanooga and St. Louis Railway, though it would be 1894 before the line would reach its terminus at Pikeville. Service on the line was provided up to the 1980s, when a decline in traffic on the branch forced a cutback in the line's operation and service was dropped to Jasper and points north. Now the depot serves as town hall. (From the author's collection.)

Audley and Mary Condra were the station agents at Cedar Springs, Tennessee. Cedar Springs, shown as Condra's Switch on the railroad timetable, was a flag stop and pre-pay freight station on the Pikeville Branch and was operated out of the general store owned by the Condras. Audley Condra was the local postmaster and the paymaster for the railroad section gang that maintained the line between Jasper and Whitwell. He was murdered on the night of January 2, 1925, by two gunmen who were hoping to steal the section gang's pay, not knowing that they had been paid earlier that day. One of the gunmen was executed and the other died in the Tennessee State Prison ten years later. (Courtesy William A. Varnell.)

Here is an old-time section gang, posing with their hand car, most likely on one of the Nashville, Chattanooga and St. Louis Railway branch lines at the turn of the century. Judging by the attire of some of the men, it would appear that the photograph was staged when the men were not working, as four of the men are wearing jackets. (Courtesy Tennessee Valley Railroad Museum.)

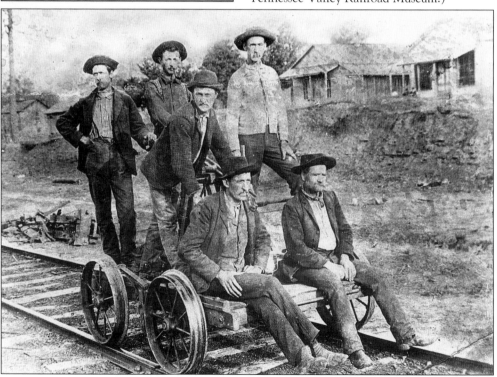

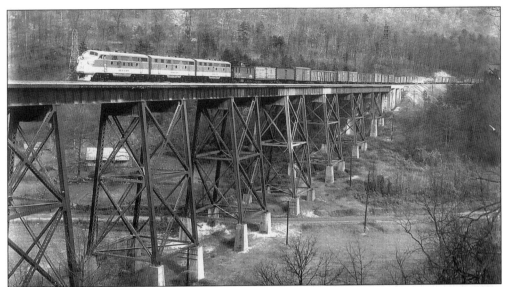

A Nashville-bound freight train crosses Running Water Creek as seen in this photograph taken by railroad photographer H.C. Hill Sr. This bridge, at 115 feet tall, was the highest bridge on the Nashville, Chattanooga and St. Louis Railway and was a target during the Civil War. Three of the massive steel piers were removed and replaced with concrete piers when Interstate 24 was built between Chattanooga and Nashville in the 1960s. (Courtesy Tennessee Valley Railroad Museum.)

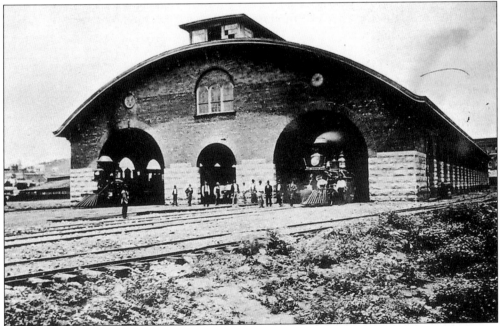

Two trains are preparing to depart the Car Shed at Chattanooga in this 1872 scene. Constructed in 1858, the Car Shed and later Union Depot were the only passenger rail facilities in Chattanooga until Cincinnati Southern and Alabama Great Southern Railways opened Central Depot on Market Street in 1888. Most of the Car Shed would be removed in 1926, with the last remainder standing until 1972. (Courtesy David H. Steinberg.)

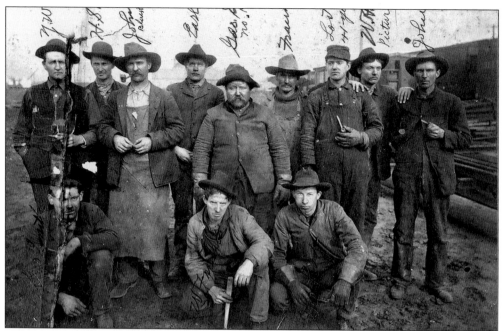

This photograph was taken in 1908 at the Nashville, Chattanooga and St. Louis Railway Craven's Yard in Chattanooga. While photographs of railroad employees were themselves common, it is a rare photograph in which most of the employees are identified. They are, from left to right, as follows: (standing) J.W. Thorton, Harry S. Phillips, John Wilson-Blacksmith, Earl McKinney, George "Fatty" Shaw, Frank Worley, unknown, W.A. Shaw, and John Knight; (kneeling) George Smith, W.F. Mathis, and George Long. (Courtesy Tennessee Valley Railroad Museum.)

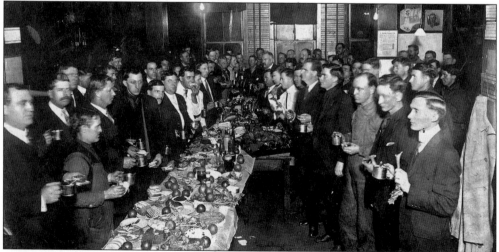

In the old days when employees could expect their employers to look after them to a certain degree, it was not uncommon for the railroads to provide meals to the employees who had to work on holidays. This photograph, taken at 2:00 a.m. on Christmas Day, 1913, shows a group of Nashville, Chattanooga and St. Louis Railway employees enjoying sandwiches and fresh fruit and vegetables in the yardmaster's office at Craven's Yard. (Courtesy Tennessee Valley Railroad Museum.)

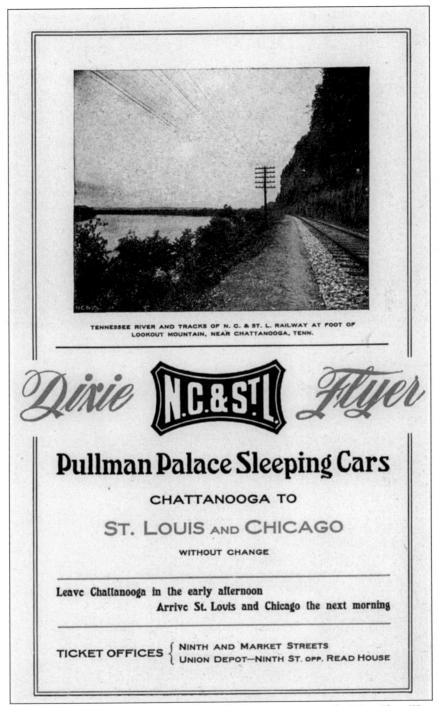

One of the more famous trains to operate through Chattanooga was the *Dixie Flyer* (Train Nos. 1 and 2, later Nos. 94 and 95), which ran from Chicago to Miami. This ad appeared in the menu of the Union Depot restaurant between 1910 and 1920, showing the railroad's line running along the banks of the Tennessee River at the foot of Lookout Mountain. (From the author's collection.)

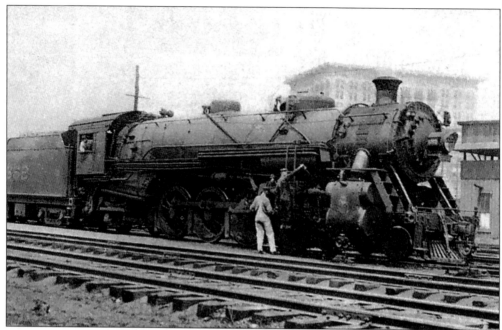

Here, the crew of Nashville, Chattanooga and St. Louis Railway No. 552 is oiling the locomotive while awaiting departure time at Union Depot. They will take Train #94, the northbound *Dixie Flyer*, on to Nashville, where it will be handed over to the Louisville and Nashville Railroad for the next leg of its journey. (Courtesy David H. Steinberg.)

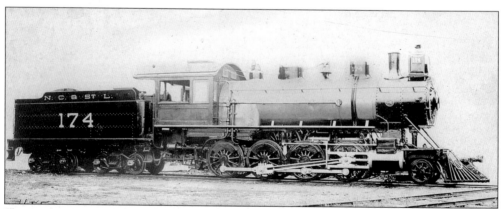

Shown above is Locomotive No. 174, an H6-37 class locomotive built by Baldwin Locomotive Works in 1902. It is of the same locomotive class as No. 191, the locomotive that crashed into Union Depot's head building on April 5, 1905. Rebuilt in 1915, No. 174 was renumbered to 374 and seved the NC until 1950 when it was scrapped.

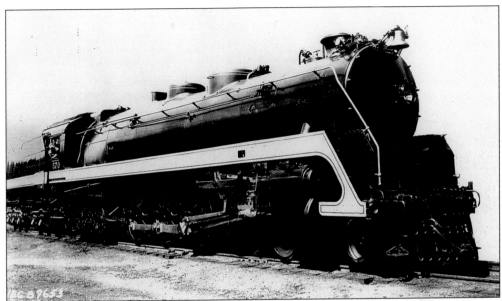

The 570 was the first J3A Dixie Class locomotive to be delivered to the Nashville and Chattanooga (NC). It was built in 1942 by the American Locomotive Company. NC employees referred to the J3As as "Yellowjackets" or "Stripes," that being a reference to the yellow running board stripe that extended to the rear of the tender. Notice that even as late as 1942, the NC still applied its signature red crown on the smokestacks of the new locomotives. (Photo by H.C. Hill Sr., courtesy Tennessee Valley Railroad Museum.)

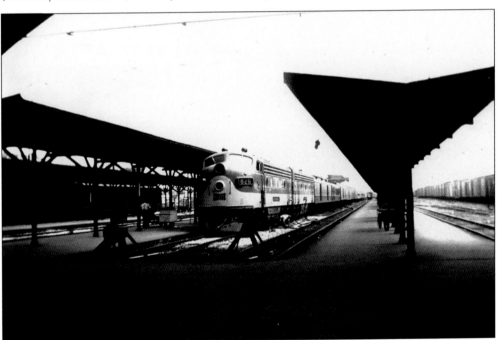

Seen here in the summer of 1955, Train No. 95, the southbound *Dixie Flyer*, has arrived at Union Depot. While the passengers detrain, the hostler fuels the train's two F-class diesel electric locomotives. (Courtesy David H. Steinberg.)

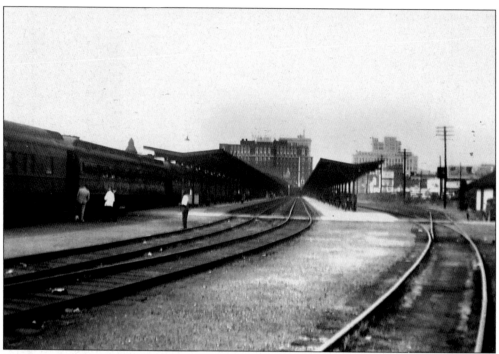

While the hostler fuels the locomotives, passengers bound for Atlanta and points south prepare to board Train No. 95 and start their journey. (Courtesy David H. Steinberg.)

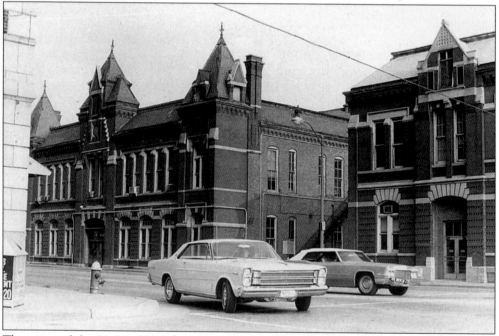

This view of the Union Depot complex, taken in the late 1960s, shows the Union Depot headhouse to the left and the Western and Atlantic Railroad freight depot on the right. These buildings were erected in 1882 and survived until 1972, when they were demolished. (Courtesy David H. Steinberg.)

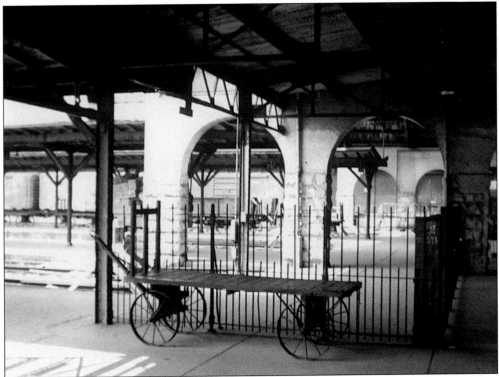

It's August 30, 1963, and the impact of the automobile and air travel on passenger trains is evident in this view of the platform area of Union Depot. Visible is the remaining portion of the old Car Shed, where the pre–Civil War locomotive *General* was displayed until 1961. (Courtesy David H. Steinberg.)

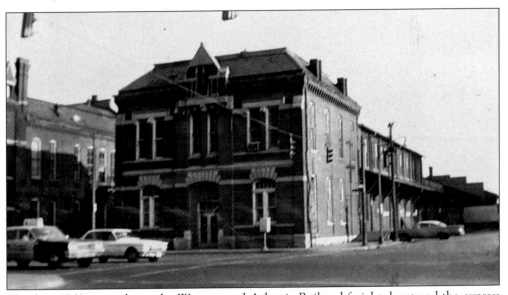

This late-1960s view shows the Western and Atlantic Railroad freight depot and the express loading dock. For a short time in the late 1960s and early 1970s, this building and Southern Railway freight depot were used by John's Railroad Salvage. (Courtesy David H. Steinberg.)

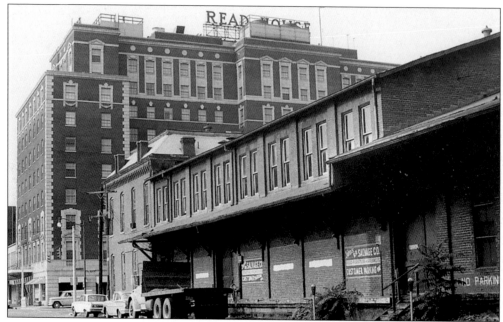

This late-1960s view of the Western and Atlantic Railroad freight depot shows the Read House Hotel. The hotel, built in the 1920s, replaced an earlier hotel and is still one of the places to stay in Chattanooga. Union Depot on the other hand was living on borrowed time. (Courtesy David H. Steinberg.)

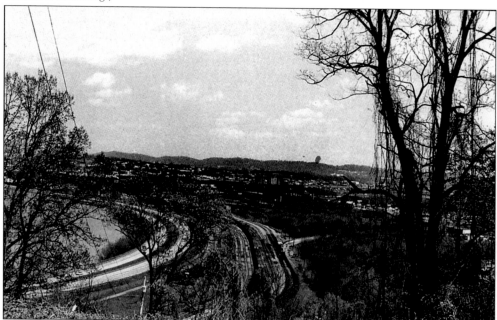

This view, looking north from Lookout Mountain in the late 1960s, shows Craven's Yard, which opened in 1900. During the late 1960s and early 1970s, railroad relocation programs led to a massive reconstruction of the railroad landscape in Chattanooga. Part of this plan was the removal of Louisville and Nashville railroad operations from Craven's Yard to the new Wauhatchie Yards, located just west of Chattanooga. (Courtesy David H. Steinberg.)

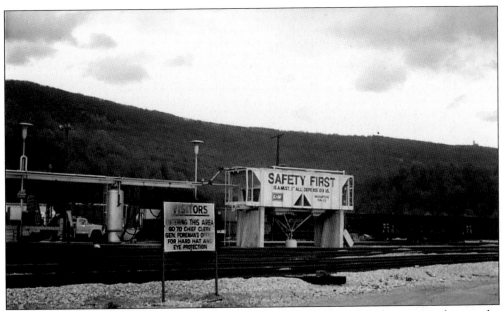

Wauhatchie Yards was the product of Plan N, the railroad relocation plan put in place in the 1950s and 1960s. It was built in the Lookout Valley just west of Lookout Mountain, replacing the turn-of-the-century Craven's Yards. The covered hopper car, doubling as a safety sign, served as the storage bin used to fill the sand bins on diesel electric locomotives serviced at Wauhatchie. (Courtesy Tennessee Valley Railroad Museum.)

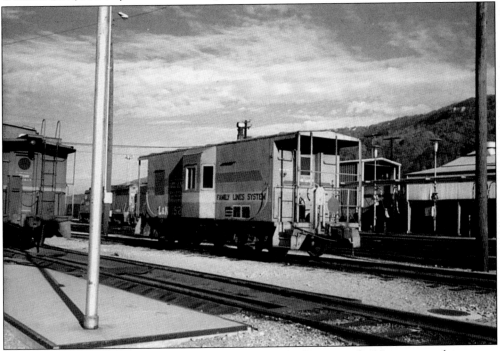

One of the service facilities at Wauhatchie was the caboose track. Here, two cabooses are awaiting their next assignment in this 1984 picture. Within a couple of years, cabooses would be banished from most freight trains. (Courtesy Tennessee Valley Railroad Museum.)

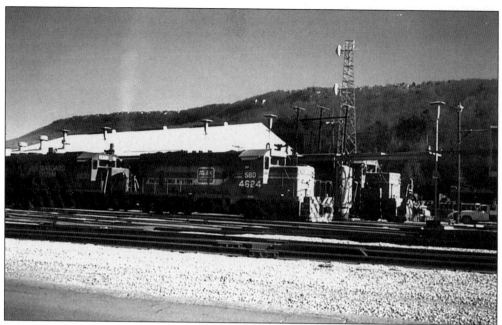

Inbound locomotives are fueled at the service facility and fuel pad at Wauhatchie Yard, where minor repairs to cars and locomotives are made as well. At the time the photographs of Wauhatchie Yards were taken, the Louisville and Nashville Railroad had been merged into the Seaboard Systems Railroad. (Courtesy Tennessee Valley Railroad Museum.)

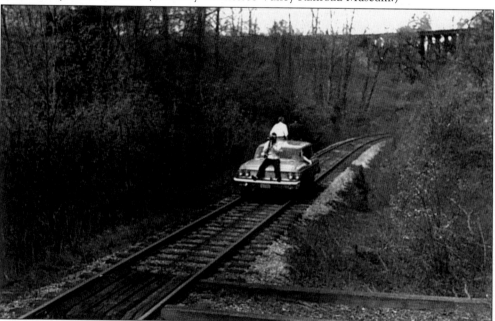

This is a full-size 1962 Ford Galaxie inspection car of the Louisville and Nashville Railroad, which was making a trip on the old line from Etowah, Tennessee, to Atlanta. Two of the car's passengers are local photographers Jimmy Samples and Herman Lamb on this April 1962 day. The car was photographed just having traversed the Hiwassee Loop. The loop trestle is visible in the upper right corner of the photograph. (From the author's collection.)

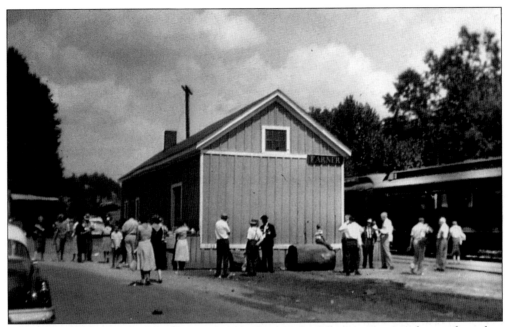

In the late 1960s, excursion trains were a popular way for folks to get out and view the colors of fall. They were also a great way for the railroads to get favorable publicity. Here, a Louisville and Nashville excursion train is stopped at Farner, Tennessee, on the Etowah-Atlanta line near the Hiwassee Loop. (Courtesy David H. Steinberg.)

Here the Louisville and Nashville excursion train is seen at the station at Etowah, Tennessee. Originally, Etowah was a division point on the railroad and the depot had offices for the division officers on the second floor of the depot. When passenger service on the Louisville and Nashville ended in 1971, ownership of the depot was transferred to the Town of Etowah. Today the depot is preserved as a public building by the town. (Courtesy David H. Steinberg.)

# Alabama & Chattanooga Rail Road,

## OFFICE OF GENERAL SUPERINTENDENT,

*Chattanooga, Tenn., Dec. 28, 1875.*

*Dear Sir:*

*The following is a list of the Officers of this Company for whom* ANNUAL PASSES *for the year 1876 are respectfully requested:*

310    F. C. Stanton,     :      Receiver and Gen'l Manager
311    C. H. Stanton,     :    :      Gen'l Superintendent
312    Thos. F. Carlile,    :   Treasurer and Purchasing Agent
313    M. Grant,    :    General Freight and Passenger Agent
314    Will R. Carlile,    :    Auditor and General Claim Agent

*Upon receipt of your list, I shall be pleased to reciprocate*

*Very Truly Yours,*

Gen'l Superintendent.

This letter, dated December 28, 1875, was sent to an official of another railroad requesting annual passes for the officers of the Alabama and Chattanooga Railroad. The handwritten numbers on the left side of the letter may be the number of the pass provided for each officer. (Courtesy Leo Myers Collection–Alan Walker.)

# Three

# EARLY SOUTHERN RAILWAY PREDECESSORS

## THE EAST TENNESSEE AND GEORGIA RAILROAD, MEMPHIS AND CHARLESTON RAILROAD, AND WILLS VALLEY RAILROAD

During the railroad development and construction boom that occurred from about 1836 to 1860, there were other railroads proposed to operate in the southeastern Tennessee region in addition to the Western and Atlantic Railroad and the Nashville and Chattanooga Railroad. It was the development of these additional connecting roads that would make Chattanooga one of the great rail junctions in the South and a target of major importance in the Civil War. All of these railroads would eventually form key portions of the Southern Railway System.

The first of the new roads was the East Tennessee and Georgia Railroad. Chartered on July 4, 1836, by the Tennessee legislature as the Hiwassee Railroad, it was authorized to raise capital and construct a railroad line from Knoxville, in East Tennessee, through the Hiwassee District in the southeastern part of the state to a point on the Tennessee-Georgia state line. On February 4, 1848, an act passed in the state legislature changed the corporate name to the East Tennessee and Georgia Railroad Company. This line was later authorized to connect with the Western and Atlantic Railroad at Dalton, Georgia, as provided for in the agreement reached between the two states in 1837. The line intentionally bypassed Chattanooga because the railroad did not feel that Chattanooga would ever develop into anything more than a small river town.

However, by the mid-1850s, it became apparent to the stockholders of the East Tennessee and Georgia Railroad Company, particularly Colonel Whiteside, that Chattanooga could become a substantial transportation and industrial center. Concerned that the railroad might effectively shut itself out of Chattanooga, the stockholders prevailed on the railroad's management to construct a branch line to extend to Chattanooga from a point on the main line near Cleveland, Tennessee. Surveying of this line most likely began in 1855, but this was the only work to be done on the proposed line running between Chattanooga and Cleveland by way of Blue Springs. The reason the work ended was simply that the Chattanooga, Harrison, Georgetown and Charleston Railroad had been grading a rail line in the same general area when it went bankrupt. This line had been authorized by the state legislature to construct a rail line from Chattanooga to connect with the East Tennessee and Georgia Railroad at a point near Charleston, Tennessee.

Rather than undertake unnecessary expenses, the East Tennessee and Georgia purchased the bankrupt railroad and resumed construction on that line between Chattanooga and Cleveland. The new owner completed the unfinished tunnel at Missionary Ridge and the grading between the tunnel and Cleveland. The tunnel was named Whiteside Tunnel in 1856 to honor Col. James Whiteside, a major stockholder in the railroad company and a great friend to the railroad. Due to the amount of work required to complete the Chattanooga Branch (the name of the branch line), it was not open for train traffic until July 3, 1859. Stations located on the line were Tyner, Ooltewah, and Sulfur Springs.

The East Tennessee and Georgia Railroad was a major target during the Civil War due to its connections to Knoxville and Atlanta. On the night of November 8, 1861, several bridges on this line and the Western and Atlantic Railroad were burned by East Tennesseans loyal to the United States. The only railroad bridge in the immediate vicinity of Chattanooga that was not burned was the East Tennessee and Georgia Railroad bridge at South Chickamauga Creek. This bridge was a three-arch stone bridge. The line was operated intermittently during the war as conditions permitted. Towards the end of the war, it was entirely operated by the U.S. Military Railroad, then restored to its owners at the end of the conflict. In 1869, the line merged with the East Tennessee and Virginia Railroad, forming the East Tennessee, Virginia and Georgia Railroad (ETV&G).

The ETV&G also grew in size and influence in Chattanooga, acquiring the lease of the Memphis and Charleston Railroad in 1877. In 1881 the officers of the Memphis and Charleston Railroad were replaced by the officers of the ETV&G. This action along with the ETV&G's acquisition of large amounts of Memphis and Charleston stock gave control of the Memphis and Charleston Railroad to the ETV&G. During the industrial growth experienced following Reconstruction, numerous improvements were made to the road's Chattanooga facilities including an additional station built at Sherman Heights (East Chattanooga) in 1887.

During the period of the East Tennessee and Georgia Railroad's construction of the Chattanooga Branch, the Memphis and Charleston Railroad was constructing its line east from Memphis towards the Atlantic Ocean. Receiving its charter from the Tennessee legislature on February 2, 1846, the Memphis and Charleston Railroad was authorized to purchase the La Grange and Memphis Railroad and to construct a line eastward to the Tennessee state line or the Tennessee River. Construction of this line, intended to link the city of Memphis with Charleston, South Carolina, began in early 1852. The line completed its connection with the Nashville and Chattanooga Railroad at Stevenson, Alabama, on March 8, 1856. Trains operating between Stevenson and Chattanooga used the Nashville and Chattanooga's main line under the joint use lease agreement previously mentioned. Passenger trains operated at an average speed of 17 miles an hour while freight trains averaged only 10 miles an hour. Delays at Chattanooga could be as long as 14 hours or more, mainly due to a lack of coordination between the connecting roads. This line was one of the main targets of the military forces during the Civil War and the main avenue for the Federal army's advance from Nashville to Chattanooga and eventually Atlanta.

Following the war and reconstruction of the railroad, the Memphis and Charleston Railroad was leased to the Southern Railway Security Company, beginning in 1872. The lease had a term of 99 years, but it only remained in effect for just over a year, with ownership returned to the railroad in 1873. The railroad was again leased out in 1877, this time to the East Tennessee, Virginia and Georgia Railroad, which by 1881 had essentially absorbed the Memphis and Charleston Railroad, integrating it into their larger operation.

Following the East Tennessee, Virginia and Georgia Railroad's lease of the Memphis and Charleston Railroad, the need for a second downtown railroad station to alleviate the overcrowded conditions became painfully evident. In early 1888, the Alabama and Chattanooga Railroad freight depot (built on Market Street in 1871) was renovated by the Alabama and Chattanooga Railroad and the ETV&G for reuse as a passenger station. The station, known as Central Passenger Depot, opened in September 1888. All passenger train

operations of the Alabama and Chattanooga; East Tennessee, Virginia and Georgia; Memphis and Charleston; and Cincinnati Southern Railroads were relocated from Union Depot to Central Depot. In 1894, these lines became part of the new Southern Railway System.

The last major railroad construction project to be started before the outbreak of hostilities was the Wills Valley Railroad. This railroad was chartered in 1853 to construct a rail line from Wauhatchie, Tennessee, to Meridian, Mississippi. Construction of the line did not commence until sometime in 1860, and by the start of the Civil War in 1861, the line had only been completed as far as Trenton, Georgia. The hostilities from 1861 to 1865 brought all work on the Wills Valley Railroad to a halt. Construction was not resumed until 1867, when the Alabama legislature passed a bill permitting state endorsements guaranteeing payment of principle and interest on first-mortgage railway bonds. This act of the legislature paved the way for two carpetbaggers, John C. Stanton and his brother Daniel, to bring Northern money to the road. John Stanton reorganized the Wills Valley Railroad as the Alabama and Chattanooga Railroad.

Construction of the line was completed on May 17, 1871, notwithstanding the fact that the railroad had defaulted on the interest of the bonds due on the first of that year. The railroad's default on the bonds and the labor problems that persisted throughout the 1870s were largely due to the fact that much of the money that should have gone towards interest payments and laborers' wages was spent by John Stanton on his luxury hotel at Chattanooga, the Stanton House. In the summer of 1871, the road was placed in receivership, and the States of Alabama and Georgia eventually took over the operation of the portions of the line within their states. The depression of 1873 only made the financial condition of the road worse. Its financial condition did not improve until January 22, 1877. On that date Baron Emile Erlanger and his associates purchased the Alabama and Chattanooga Railroad. The new owners reorganized the road as the Alabama Great Southern Railway, a British corporation, and they improved the physical condition of the line.

In the early 1880s, the Alabama Great Southern Railway would participate in interline passenger and freight operations with the Cincinnati Southern and New Orleans and Northeastern Railroads, forming the Queen and Crescent Route with through passenger service between Cincinnati, Ohio, and New Orleans, Louisiana. In 1895, the Alabama Great Southern Railway was taken over by the Southern Railway System. Eventually, the other roads that made up the Queen and Crescent Route were also taken over by the Southern, and by 1917 all reminders of the Queen and Crescent Route were eliminated with the exception of Train Nos. 3 & 4, the Queen and Crescent Limited. Eventually those train numbers were reassigned to the Royal Palm, a Cincinnati-Jacksonville train.

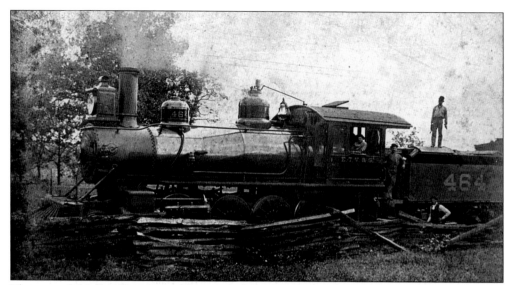

The crew of this East Tennessee, Virginia and Georgia Railroad train took a moment from their duties to pose for the camera with their locomotive, No. 464, in the early 1890s. This locomotive was one of a class of compound steam locomotives built in 1890 by the Schenectady Locomotive Works. It was renumbered in 1894 when the railroad company was merged into the new Southern Railway System. The locomotive was scrapped in the 1930s. (From the author's collection.)

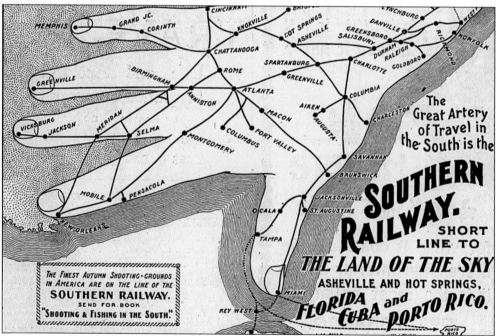

The Southern Railway was a product of the amalgamation of a number of Southeastern railroad companies by the J.P. Morgan syndicate in 1894. This advertisement, which appeared in 1898, was produced to convince the travelers considering a trip to the Carolinas, Florida, or the Caribbean that the Southern was the logical short line to their destination. (From the author's collection; reproduced with permission from Norfolk Southern Corporation.)

# Four

# POST-WAR RAILROADS AND IMPROVEMENTS

## THE CINCINNATI SOUTHERN RAILROAD; CHATTANOOGA, ROME AND COLUMBUS RAILROAD; AND THE CHATTANOOGA SOUTHERN RAILROAD

Following the end of the Civil War, the growth of the Chattanooga area was again fueled by a need for the opening of a new transportation route. With the infusion of Northern capital and the rapid industrialization of the region, the people of Chattanooga desired a more direct route for goods to be sent between Chattanooga and the cities of the central Northern states. Similarly, some leading citizens of Cincinnati, Ohio, desired a more direct transportation route to connect their region with the southeastern states and their markets. In the early 1870s, railroad organizers proposed to build the Cincinnati Southern Railroad from Cincinnati, Ohio, to Chattanooga. This proposal was met with a great degree of enthusiasm by the Chattanoogans, who approved the purchase of bonds by the City in the amount of $10,000 on July 12, 1873.

As it turned out, the entire construction of the railroad was financed by municipal bonds sold by the City of Cincinnati, making the Cincinnati Southern Railroad the largest municipally owned railroad at the time. Surveying and construction of the line began in 1874 and the construction work was started out of both cities to accelerate the completion of the line. One of the first tasks facing crews in Chattanooga was the construction of the massive Tennessee River drawbridge below Chickamauga Island. The total length of the bridge and its approaches was some 1,500 feet, with the swing span drawbridge at the north end of the bridge. Construction on the Chattanooga end was slowed in the late summer of 1878 by a yellow fever outbreak. However, the pace of the work picked up rapidly in late 1878 and early 1879, and Cincinnati Southern officials could be frequently seen in town as the line neared completion.

On the night of December 11, 1879, the last rails were joined inside the Robbins Tunnel in northeastern Tennessee. Shortly thereafter, the line was put into regular operation. The formal celebrations one would expect to accompany the completion of the railroad included two excursions over the length of the railroad and formal banquets for the invited guests. The first excursion, from Chattanooga to Cincinnati, went as planned on March 17, 1880, and the banquet held at the Cincinnati Music Hall the following evening. The following month Chattanooga played host to its guests from Cincinnati, entertaining them with a day trip. Due to the size of the party, there were not enough vehicles to transport all of the guests to Lookout Mountain to enjoy the scenery, so some guests were escorted on a riverboat for a daytrip to

Shellmound. The banquet for the excursionists was held at the Stanton House. In 1881, the railroad became an affiliate of the Queen and Crescent Route. In 1894, the Cincinnati Southern Railroad was leased to the Cincinnati, New Orleans and Texas Pacific Railway, a Southern Railway subsidary. The Cincinnati Southern, along with the Alabama Great Southern Railway (by then another Southern Railway subsidiary), continued to operate under the Queen and Crescent Route banner until 1917.

By the late 1880s, it had become quite apparent that Chattanooga's desire for more and more rail lines would not be easily sated. At the time, Chattanooga had direct links with Cincinnati, Nashville, Memphis, Atlanta, New Orleans by way of Meridian, as well as Washington and points northeast by way of Knoxville, and still more railroads were being proposed. One such rail line would connect Chattanooga to Griffin, Georgia, where a connection with the Central of Georgia Railroad was made. This line was chartered as the Chattanooga, Rome and Columbus Railroad. Completed on June 27, 1888, it connected Chattanooga to Griffin by way of the Georgia towns of Chickamauga, LaFayette, Rome, and Cedartown. This line later became part of the Central of Georgia Railway. The Central of Georgia Railway was the first line serving Chattanooga to terminate passenger service out of the city, the last runs of Train No. 2 taking place on New Year's Eve, 1950. The reason for the discontinuance of passenger service was directly related to the opening of improved roads and the increase in competition from buses and private automobiles.

Additional changes were in store for the Central. On June 20, 1957, the railroad dedicated a new yard and freight facility located to the south of the original Chattanooga yard. This marked the completion of the first phase of the Chattanooga rail relocation project known as Plan N. Southern Railway acquired the Central of Georgia in 1969, shortly after having been unsuccessful in taking the lease of the Western and Atlantic Railroad from the Louisville and Nashville Railroad earlier that year. Following the acquisition of the Central, much of the freight traffic was diverted to the Southern Railway's main lines. Slowly over a long period of time, sections of the Central of Georgia were taken out of service, eliminating unneeded duplicate routes and thwarting any possible competition for freight traffic by the Southern's rivals.

The Central of Georgia had two branch lines of importance in the Chattanooga area. One was the line to the Durham mines on the Georgia side of Lookout Mountain. Built as the Chattanooga and Durham Railroad in 1891, it was intended to serve as a conveyance for passengers as well as coal from the mines to the connection with the Chattanooga Southern at present-day Cenchat, Georgia. Later the line was extended to Chickamauga, Georgia, where some coke ovens were built. The original expectation was that eventually a resort community would be established at Lula Lake on Lookout Mountain. While the resort never developed, coal mining continued on the mountain until 1964. Rail service to the mines ended sometime around 1947, and by 1952 the rail lines had been removed. The second important branch line was built around the turn of the century, providing the military base at Fort Oglethorpe, Georgia, with rail transportation. This line was abandoned in the mid-1950s—though the tracks were not taken up until sometime in the early 1970s.

The last trunk railroad to be constructed in the Chattanooga area was not built to the city, but from the city. In the 1880s, Chattanooga was eagerly vying for the title "Pittsburgh of the South." To reach that end, a railroad was needed to access large iron ore deposits believed to be in the Gadsden, Alabama area. This railroad would provide an economical means to transport the iron ore and coal from mines in the same area to Chattanooga while providing a secondary route for through passenger trains to New Orleans and lower Alabama via Gadsden and the Louisville and Nashville Railroad.

The first concrete steps towards the construction of this road began on October 24, 1887, when the State of Georgia granted a charter to the Chattanooga Southern Railway Company. No charter was needed in Tennessee, as the plans for the railroad did not call for any construction in Tennessee. The line would be constructed from a point on the Union Railway

at the Tennessee-Georgia state line because the Chattanooga Southern would use the existing Union Railway to access Chattanooga. At this time, the Union Railway was controlled by Charles E. James, a major stockholder and proponent of the Chattanooga Southern.

The actual construction of the line began with surveying on March 17, 1888, followed by the groundbreaking for construction on March 28, 1889. Due to financial hard times, the progress of the work was inconsistent. On May 3, 1890, a charter was secured in the State of Alabama. By June of that year, several miles of line had been completed northward from Gadsden, while the line from Chattanooga had been finished as far as Kensington, Georgia. The entire 92-mile line was completed just over a year later, on June 10, 1891, at Pigeon Mountain tunnel, and through freight service was introduced. Passenger trains, operating from the Union Railway Depot on Georgia Avenue, commenced on June 23, 1891. Shortly thereafter, plans for the extension of the line towards Talladega, Alabama, and LaGrange, Georgia, were announced.

Unfortunately for the road, such plans would never come to fruition. It soon became apparent that there was not sufficient through freight, through passenger, and local traffic to support the railroad. The fact that much of the iron could not be economically mined only made the survival of the line more unlikely and forced it into receivership. In all, the company would be forced into receivership three times. Through the wise management of a succession of receivers and owners, the railroad was slowly turned from a financial failure to a profitable short line that paid dividends. These men included Newton Erb, Charles E. James, William Coverdale, and the Siskin brothers. It was under Erb that the railroad was reorganized as the Tennessee, Alabama and Georgia Railroad (TAG) on January 3, 1911.

Passenger train service on the TAG was somewhat different from that provided by the other lines serving Chattanooga. Running only one round trip daily from Chattanooga to the small communities served by the TAG, it was eventually determined that the operation of a traditional steam-powered passenger train could not be financially justified. On Monday, September 4, 1922, the last regularly scheduled steam-powered passenger train ran over the TAG. The following day, all passenger service operations were provided using new 42-seat Brill M55 model gasoline motorcars. Two units, the 500 and 501, were purchased. The 500 was the regular car and the 501 was used as a backup car. The two cars operated the passenger service affectionately known by locals as the "Pigeon Mountain Scooter" until the demise of passenger service on the line on January 31, 1951. However, the TAG was used by the Southern to detour passenger and freight trains whenever the Alabama Great Southern line or the Chattanooga-Atlanta line was blocked for some reason.

In 1955, the Southern Railway attempted to eliminate the competition provided by the TAG. The Southern refused to accept cars at interchange in either Gadsden or Chattanooga if they could have been routed between those points over the Alabama Great Southern Railway. The TAG took this case to the Interstate Commerce Commission, which ruled in the TAG's favor the following year. Towards the end of 1964, the Southern Railway announced that it intended to purchase the TAG and, on December 8, 1970, the story of the TAG reached its conclusion when the Interstate Commerce Commission approved the purchase. Throughout 1971, the railroad's five locomotives were repainted in Southern Railway colors, and within a few years much of the old TAG route would be abandoned. Today only the section between Chattanooga and Kensington is operated in freight service.

One of the byproducts of the rapid railroad development was the overload of the passenger facilities of Union Depot and Central Passenger Depot. By 1900, conditions at Central Depot, built by the Alabama and Chattanooga and East Tennessee, Virginia and Georgia Railroads in 1888, had become so unbearable that the Southern Railway System began drawing up plans for a larger terminal station. In September 1905, the Southern Railway bought the old Stanton House hotel and 51 other properties that would have to be removed for the construction project. Contracts for the grading of the station grounds and construction were let in 1906. The plans approved for the head building were the work of New York architect Donn Barber, who submitted drawings he had used in a competition in Paris, France, in 1900 when he was

studying architecture at the Beaux Arts Institute. From those award-winning plans, the basic design of the head building emerged, though the interior was modified upon the request of Southern Railway's President, Samuel Spencer. Construction of the building began on June 17, 1907, and the facility opened for service on December 1, 1909. Unlike Union Depot, the Southern Terminal Station would have a relatively uneventful career, faithfully serving the Southern's patrons until the demise of passenger service on August 11, 1970, when Train No. 18, the *Birmingham Special* was discontinued.

During the period in which Terminal Station was taking form, the Southern took aim at another of its major headaches in Chattanooga: the joint trackage operations involving Southern trains over the Nashville, Chattanooga and St. Louis Railway between Chattanooga, Wauhatchie, and Stevenson. In order to bypass the Nashville, Chattanooga and St. Louis Railway, it undertook the construction of the Stevenson Extension, which would reach as far as Stevenson, Alabama, when completed. Work was begun on this extension in 1905 and called for the construction of a 1,300-foot tunnel through the base of Lookout Mountain along with numerous bridges, the largest one crossing the Tennessee River near Guild, Tennessee. Work on the Lookout Mountain Tunnel was completed in 1908, though the construction project was marred by an unsafe blast that went off on May 16, 1907. Unfortunately, a financial panic that followed shortly thereafter prevented the railroad from completing the project and by the outbreak of World War II, the entire idea had been permanently shelved.

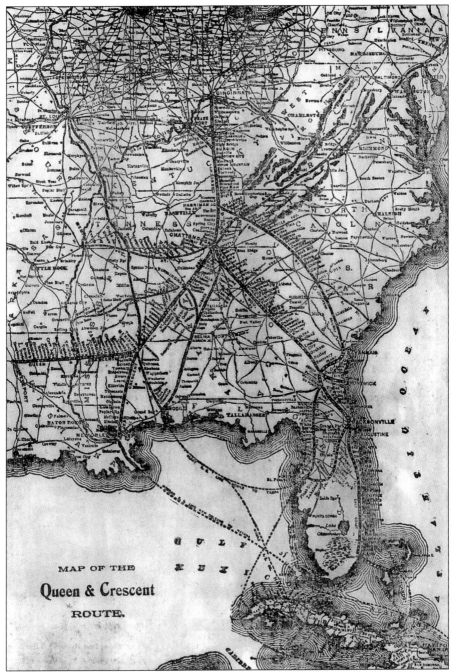

The Queen and Crescent Route was the primary railroad artery between the industrial centers of the Northern states and the Gulf Coast. The three major railroads that made up the Queen and Crescent Route consisted of the Cincinnati, New Orleans and Texas Pacific Railway, the Alabama Great Southern Railway, and the New Orleans and Northeastern Railroad. These railroads later became part of the Southern Railway System in 1894. The Queen and Crescent marketing banner was used by the Southern Railway until the 1920s. (From the author's collection; reproduced with permission from Norfolk Southern Corporation.)

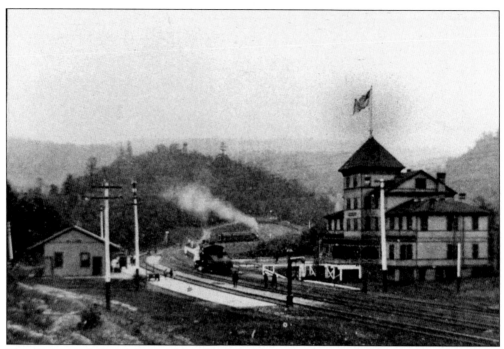

The Queen and Crescent station at Oakdale, Tennessee, was a major division point at the south end of the Cincinnati Southern Railroad's Third District, between Chattanooga and Danville, Kentucky. South of Oakdale, the Southern Railway built a connecting line to Knoxville. Robbin's Tunnel, the site of the completion of the railroad in 1880, was located to the north of Oakdale. (Courtesy David H. Steinberg.)

Chattanooga in the pre-automobile days was actually a group of small, outlying communities which lay along the Southern Railway. There were stations at Hixson, Chickamauga, Boyce, East Chattanooga, and Ooltewah—all of which are now within the corporate limits of Chattanooga. Here, patrons are awaiting the next train at Boyce Depot in July 1913. This building replaced a previous structure that burned in 1912. It was removed and replaced in the 1940s. (Courtesy R.E. True/David H. Steinberg.)

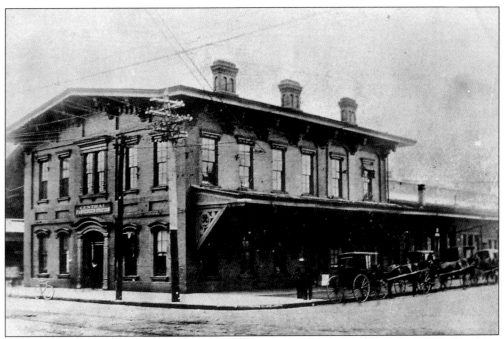

From September 1888 to December 1909, all passenger trains of the Alabama and Chattanooga Railroad, the Memphis and Charleston Railroad, the Cincinnati Southern Railway, and the East Tennessee, Virginia and Georgia Railroad used the Central Passenger Depot as their Chattanooga passenger terminal. Central Depot, located at the corner of Market and King Streets, was originally built in 1871 as the Alabama and Chattanooga Railroad freight depot. (Courtesy David. H. Steinberg.)

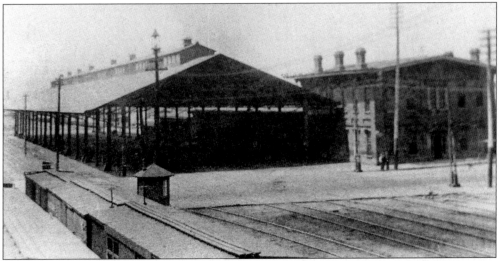

Central Depot, built originally as a freight depot, was converted to a passenger facility in 1888 to alleviate the overcrowded conditions at Union Depot. To provide a suitable area for a passenger platform, a large iron shed was constructed. Following the closure of Central Depot in 1909, the shed was sold for scrap. Central Depot continued to be used as office space and warehouse space until 1923, when the Southern Railway erected an office building on that site. (Courtesy David H. Steinberg.)

Known locally by its street address—1301 Market Street—this office building was constructed by the Southern Railway in 1923 on the site of Central Depot. It allowed the Southern Railway to consolidate their offices, which had previously been spread out in several downtown locations. By the 1990s, the railroad had relocated many of the offices, and in 2002, the building was sold to a developer and redeveloped as a combination commercial/residential building while retaining its historical exterior. (From the author's collection.)

This building, located just to the rear of the 1301 Market Street office, is all that remains of the Central Depot complex. Originally it would have been part of the baggage and express building. Cut down to its present size, the building now serves as commercial retail space. (From the author's collection.)

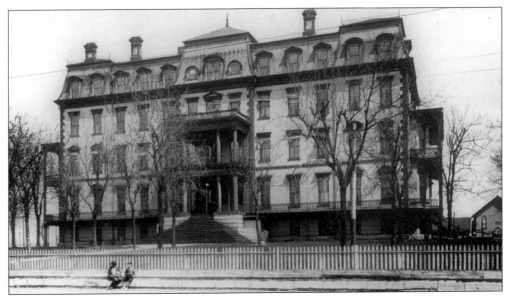

This grand building is the Stanton House. Built in 1871 by the president of the Alabama and Chattanooga Railroad, John C. Stanton, this hotel was the primary reason that the Alabama and Chattanooga Railroad eventually went bankrupt. Stanton preferred to invest the profits of the railroad in this hotel rather than paying the railroad's employees and creditors. The once grand hotel is seen here in 1895, a mere ten years before its demolition. (Courtesy Chattanooga Choo Choo.)

This was the first view that greeted guests arriving at the Stanton House: the entry vestibule and front desk. Once the grand hotel of Chattanooga, by 1895, the 100-room luxury hotel was in its decline. This was due to the relocation of the city's business center from Montgomery Avenue to the present location along Market Street north of Ninth Street. By 1905, hotel proprietor Z.C. Patton was more than happy to sell the property to Southern Railway for use as a site for their new Terminal Station. (Courtesy Chattanooga Choo Choo.)

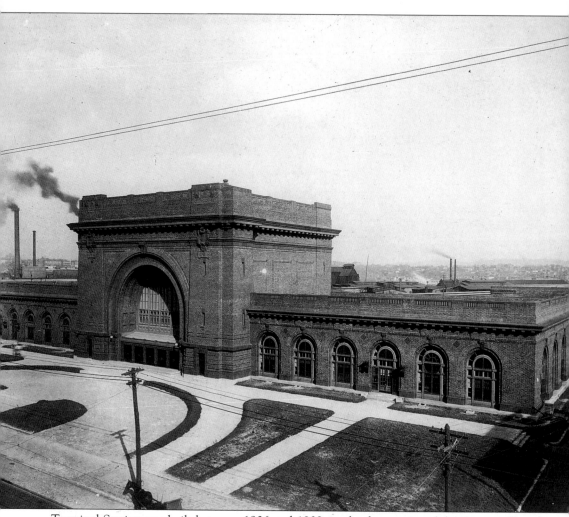

Terminal Station was built between 1906 and 1909 on the former site of the Stanton House. When it opened for business on December 1, 1909, it was one of the grandest stations in the South. New York architect Donn Barber designed the structure by using award-winning plans that Barber had drawn up as a student at the Beaux Arts Institute in Paris, France. Here, Terminal Station is seen sometime prior to its opening in 1909. (From the author's collection.)

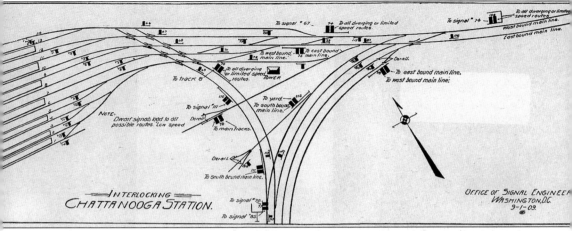

Terminal Station had 14 tracks serving 7 platforms. This drawing shows the arrangement of Terminal Station's tracks and the interlocking plant that controlled access to the station. The plant was rebuilt in 1945 when a new interlocking machine was installed, replacing the original Armstrong interlocking machine. (Courtesy David H. Steinberg.)

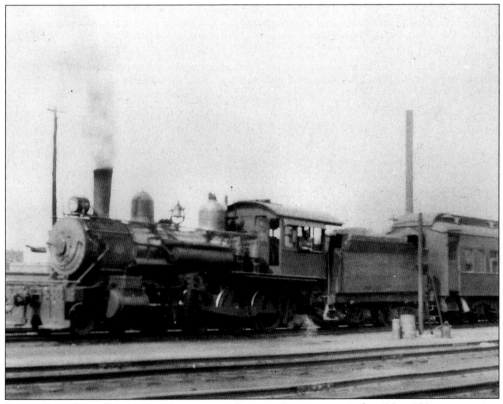

Pictured on June 24, 1925, Chattanooga Station Company switcher No. 100 was moving passenger cars around Terminal Station. Switchers were used to move passenger cars between the Terminal Station and the coach yard, where the cars were tended to between trips. (Courtesy David H. Steinberg.)

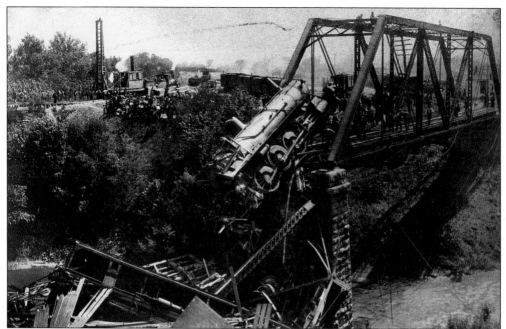

Occasionally train wrecks did occur in Chattanooga. This wreck occurred on May 16, 1907, at the west end of Nashville, Chattanooga and St. Louis (NC&StL) Craven's Yard. A blast at the site of the Southern Railway's Lookout Mountain Tunnel was prematurely set off. Rocks from the blast struck the tension rods of the NC&StL, causing it to collapse under a Southern Railway freight train as it crossed the bridge. One Southern Railway employee and two NC&StL employees were killed in this incident. (From the author's collection.)

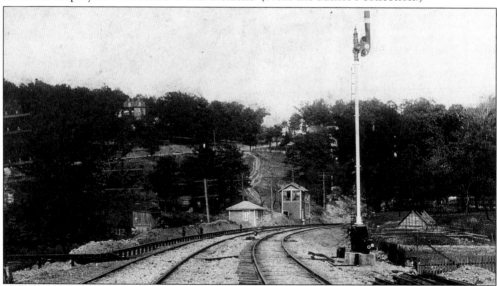

On this day, the operator at VM Tower has lined up a route for an eastbound train and cleared the home signal for the train movement to pass. Just beyond the signal is a split-point derail. When the signal was at its normal position-stop, the derail would open. Any train overrunning the stop signal without permission from the operator would derail, preventing it from entering the main track and the tunnel beyond. (Courtesy Tennessee Valley Railroad Museum.)

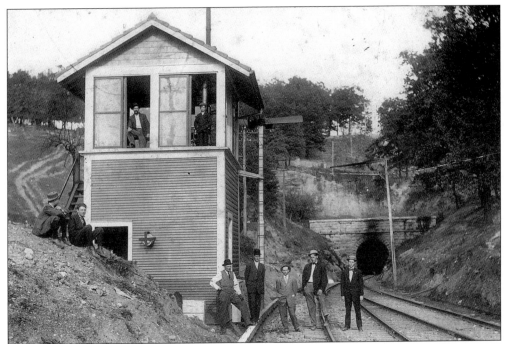

In 1912, the Southern Railway System double tracked the main line between Chattanooga and Ooltewah, Tennessee, except for the Whiteside Tunnel at Missionary Ridge. VM Tower was constructed in 1912 to control train traffic through that chokepoint and served until control of the VM Tower interlocking plant was transferred to Citico Tower in the 1930s. The three men at the center of the row are (from left to right) Ira K. Hall, Calvin Cash, and Fred Redwine (later a local attorney), all of whom were operators assigned to VM Tower. (Courtesy Tennessee Valley Railroad Museum.)

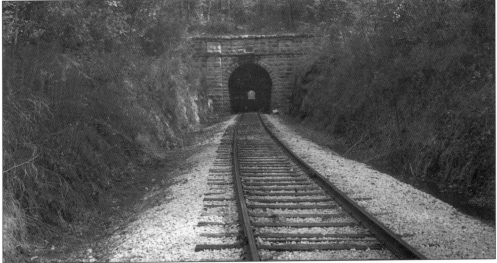

This view shows the ET&G line at Whiteside Tunnel today, as rebuilt by Tennessee Valley Railroad museum in the 1970s. This line was removed by Southern Railway in 1954 and the rails through the tunnel taken up. The site of VM Tower is to the photographer's back. (Courtesy Tennessee Valley Railroad Museum.)

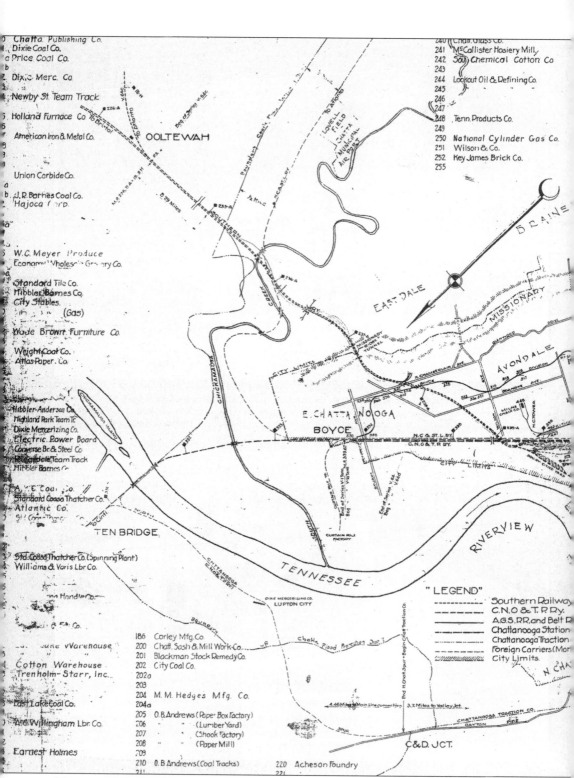

This map of the Southern Railway System's Belt Railway of Chattanooga provides a very good overview of the geographical arrangement of the railroads in Chattanooga. Each of the

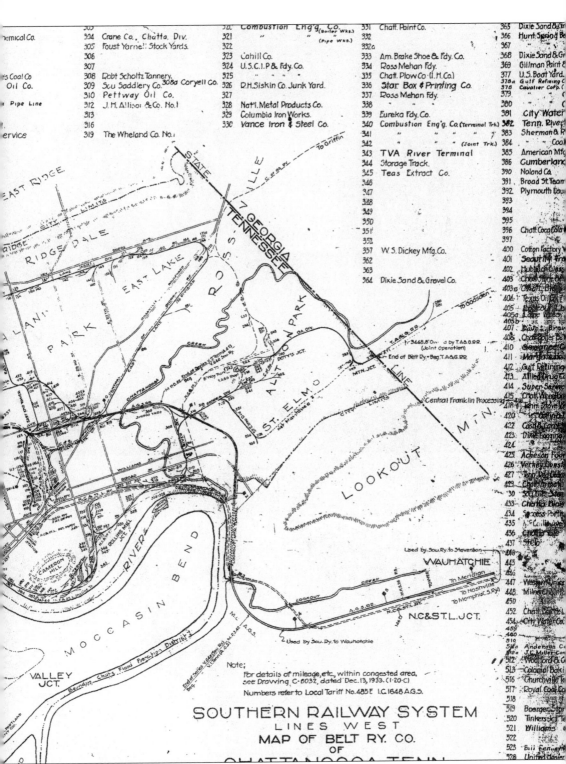

| | | | | | | |
|---|---|---|---|---|---|---|
| | 304 | Crane Co., Chatta. Div. | 321 | Combustion Eng'g. Co. (Boiler Wks.) | 331 | Chatt. Paint Co. |
| hemical Co. | 305 | Foust Yarnell Stock Yards. | 322 | " " (Pipe Wks.) | 332 | |
| | 306 | | 323 | Cahill Co. | 332a | |
| es Coal Co | 307 | | 324 | U.S.C.I.P. & Fdy. Co. | 333 | Am. Brake Shoe & Fdy. Co. |
| Oil Co. | 308 | Robt Scholtz Tannery. | 325 | | 334 | Ross Mehan Fdy. |
| | 309 | Sou Saddlery Co. 308a Coryell Co. | 326 | D.H. Siskin Co. Junk Yard. | 335 | Chatt. Plow Co. (I. H. Co.) |
| Pipe Line | 310 | Pettway Oil Co. | 327 | | 336 | Star Box & Printing Co. |
| | 312 | J. H. Allison & Co. No. I | 328 | Nat'l. Metal Products Co. | 337 | Ross Mehan Fdy. |
| | 313 | | 329 | Columbia Iron Works. | 338 | |
| | 316 | | 330 | Vance Iron & Steel Co. | 339 | Eureka Fdy. Co. |
| ervice | 319 | The Wheland Co. No. I | | | 340 | Combustion Eng'g. Co. (Terminal Trk.) |

| | | |
|---|---|---|
| 341 | " " " (Joint Trk.) | |
| 342 | | |
| 343 | TVA River Terminal | |
| 344 | Storage Track. | |
| 345 | Teas Extract Co. | |
| 346 | | |
| 347 | | |
| 348 | | |
| 349 | | |
| 350 | | |
| 351 | | |
| 352 | | |
| 357 | W. S. Dickey Mfg. Co. | |
| 362 | | |
| 363 | | |
| 364 | Dixie Sand & Gravel Co. | |

| | |
|---|---|
| 365 | Dixie Sand & Gr |
| 366 | Hunt Spring Be |
| 367 | |
| 368 | Dixie Sand & Gr |
| 369 | Gillman Point & |
| 377 | U.S. Boat Yard. |
| 378a | Gulf Refining Co |
| 378 | Cavalier Corp. |
| 379 | |
| 380 | City Water |
| 381 | Tenn. River |
| 382 | Sherman & R |
| 383 | |
| 384 | Coal |
| 385 | American Mfg |
| 386 | Cumberlan |
| 390 | Noland Co |
| 391 | Broad St. Team |
| 392 | Plymouth Laur |
| 393 | |
| 395 | |
| 396 | Chatt. Coca Cola |
| 397 | |
| 400 | Cotton Factory |
| 401 | Security Iron |
| 402 | Hubbach Glass |
| 403 | Chem. Dye |
| 404 | Texas Oil Co |
| 407 | |
| 408 | Chatt. Boiler Co |
| 410 | |
| 411 | |
| 412 | Gulf Refining |
| 413 | Allied Drug Co |
| 414 | Super Service |
| 415 | Chatt. Wheel |
| 416 | Tenn. Stove Wo |
| 420 | |
| 422 | Cash & Carden |
| 423 | Dixie Logging |
| 424 | |
| 425 | Acheson Fou |
| 426 | Verhey Constr |
| 427 | Tenn. Red Cedar |
| 428 | |
| 430 | Sou Chem Co |
| 433 | Chatt. Box |
| 434 | Success Portla |
| 435 | |
| 436 | Cross Co |
| 437 | Stelo |
| 445 | |
| 446 | |
| 447 | Western River |
| 448 | Milne Chair Co |
| 450 | |
| 452 | Chatt. Box |
| 454 | City Water Co |
| 459 | |
| 460 | |
| 510 | |
| 511a | Anderson Co |
| 512a | J. C. Miller Co |
| 512 | Wexford & Co |
| 513 | Colonial Baki |
| 516 | Churchville T |
| 517 | Royal Coal Co |
| 518 | |
| 519 | Boerger Stor |
| 520 | Tinkers of Te |
| 521 | Williams |
| 522 | |
| 523 | Bill Fenney |
| 528 | United Dealer |

Note;
For details of mileage, etc., within congested area,
see Drawing C-6032, dated Dec. 13, 1933. (I-20-C)

Numbers refer to Local Tariff No. 485E I.C. 1648 A.G.S.

## SOUTHERN RAILWAY SYSTEM
### LINES WEST
## MAP OF BELT RY. CO.
### OF
CHATTANOOGA, TENN.

industries served is denoted on the map by name and location. (Courtesy Tennessee Valley Railroad Museum; reproduced with permission from Norfolk Southern Corporation.)

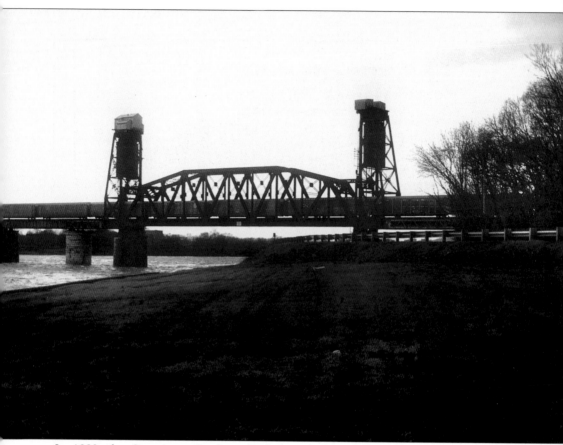

In 1880, the Cincinnati Southern Railway completed its line from Cincinnati, Ohio, to Chattanooga. Just north of Chattanooga, the line crossed the Tennessee River using a drawbridge. Originally a swing type bridge, the present lift span was installed in 1917, though the lift towers and machinery were not installed until 1920. (From the author's collection.)

# He's putting out a fire
# we started 123 years ago!

THE 8,000-mile Southern is now the largest railway system in the country to be 100 per cent Dieselized. We've "pulled the fire" on our last steam locomotive.

In effect, this fire was started back in 1830—when history-making *Best Friend of Charleston*, on a railroad that is now part of the Southern Railway System, became the first steam locomotive to run in regularly scheduled service in America.

Down through the years since 1830, the colorful steam locomotives paced the progress of the South, serving well until they, too, had to step aside for progress.

Today we are serving the South with a fleet of 880 powerful Diesel locomotive units costing $123½ million. This huge investment in modern power marks the Southern's faith in the future of the South, and underscores our determination to provide a great *new kind* of railroading—modern, streamlined, progressive, better than ever—for the fast-growing area we are privileged to serve.

*Harry a. DeButts*
President

One trademark of the Southern Railway System was that it was one of the most progressive railroads in the nation. In 1830, a forerunner of the Southern was the first railroad to use steam locomotives in scheduled service. In 1953, it was the first major railroad to replace all steam locomotives with modern diesel electric locomotives. This 1953 ad appeared just after the retirement of the Southern's last steam locomotive, No. 6330, in June of that year. (From the author's collection; reproduced with permission from Norfolk Southern Corporation.)

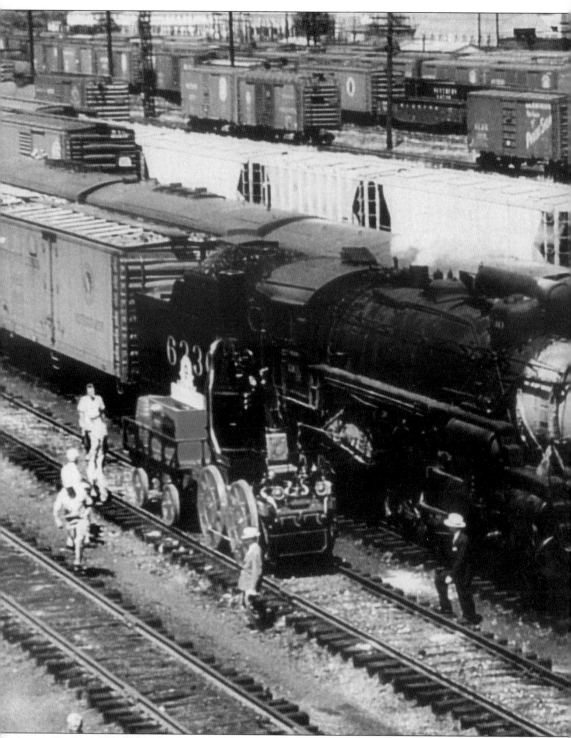

On June 17, 1953, the last steam-powered train to operate on the entire Southern Railway System arrived at Citico Yard in Chattanooga. The Oakdale-Chattanooga freight pulled up to the Third Street bridge, where it was photographed by local photographer Herman H. Lamb

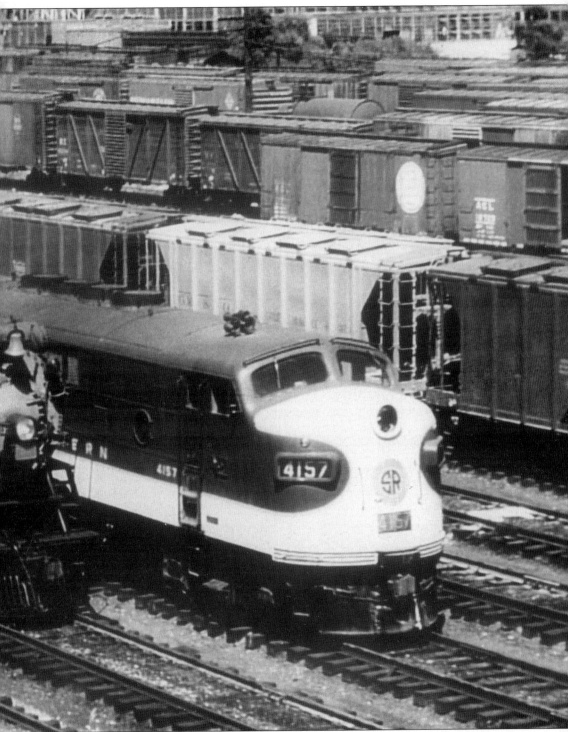

and others, standing between a replica of the *Best Friend of Charleston* and a modern four-unit freight locomotive. (From the author's collection.)

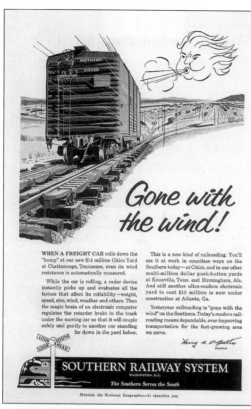

WHEN A FREIGHT CAR rolls down the "hump" at our new $14 million Citico Yard at Chattanooga, Tennessee, even its wind resistance is automatically measured.

While the car is rolling, a radar device instantly picks up and evaluates all the factors that affect its rollability—weight, speed, size, wind, weather and others. Then the magic brain of an electronic computer regulates the retarder brake in the track under the moving car so that it will couple safely and gently to another car standing far down in the yard below.

This is a *new kind* of railroading. You'll see it at work in countless ways on the Southern today—at Citico, and in our other multi-million dollar push-button yards at Knoxville, Tenn. and Birmingham, Ala. And still another ultra-modern electronic yard to cost $15 million is now under construction at Atlanta, Ga.

Yesteryear railroading is "gone with the wind" on the Southern. Today's *modern* railroading means dependable, ever-improving transportation for the fast-growing area we serve.

*Harry S. DeButts*
President

### SOUTHERN RAILWAY SYSTEM
WASHINGTON, D.C.
*The Southern Serves the South*

Mention the National Geographic—It identifies you

During the 1950s, Southern Railway made a number of improvements to its properties in Chattanooga. In 1954, the railroad completed major renovations at Citico Yard, which included the installation of a new hump yard to speed the building of outbound freight trains. This yard would later be named after Southern Railway President Harry DeButts. (From the author's collection; reproduced with permission from Norfolk Southern Corporation.)

On the night of August 3, 1953, Train No. 18, the *Birmingham Special*, backs into Terminal Station. This train was the last train to operate out of Terminal Station 17 years later. (Courtesy David H. Steinberg.)

It's a muggy afternoon at Terminal Station on September 19, 1958. Train No. 42, the *Pelican*, is standing on Track 9, taking on passengers for Washington, D.C. To the right, Train No. 4, the *Royal Palm*, takes on passengers bound for Cincinnati. (Courtesy David H. Steinberg.)

Seen here in the afternoon on July 13, 1953, Train No. 42, the *Pelican*, is arriving on Track 8. On this day a Southern Railway office car brings up the rear of the train. (Courtesy David H. Steinberg.)

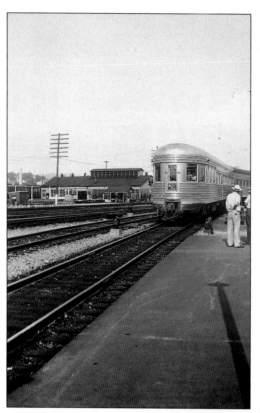

On this bright 1950s afternoon, the *Royal Palm* is backing into Terminal Station. In the late 1940s, the train was modernized with all streamlined equipment. The train would last until the end of November 1969. (Courtesy David H. Steinberg.)

The 1950s photograph below shows an outbound *Royal Palm* departing Terminal Station. Terminal Tower and the diesel oil tank for the fuel pad can be seen directly ahead. The long building to the left is a passenger car shop. The pipes and hoses are the fueling pad where diesel electric locomotives were fueled between runs. (Courtesy David H. Steinberg.)

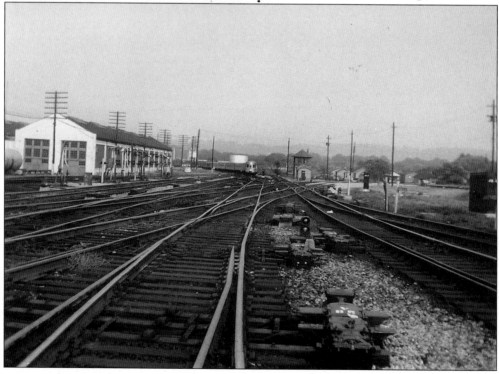

The man seated in front of the interlocking machine is Operator Waller, who worked at Terminal Tower in the 1960s. The machine shown was installed in 1945 and replaced an older interlocking machine that was installed when the station was opened in 1909. The machine pictured is now displayed on the first level of the old baggage building at the Chattanooga Choo Choo Holiday Inn. (Courtesy David H. Steinberg.)

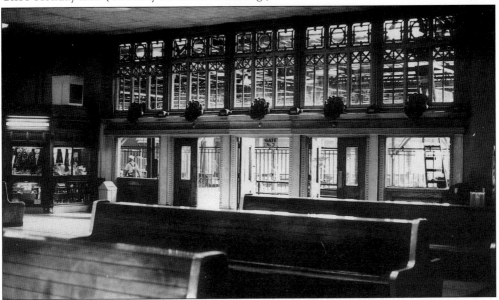

In the 1960s, a number of changes were made to Terminal Station. In an attempt to save money, a false ceiling was installed in the waiting room, obscuring the great dome. When the Chattanooga Choo Choo Company took over the property, the false ceiling was one of the first things to go, revealing the great dome to the public once again. (Courtesy David H. Steinberg.)

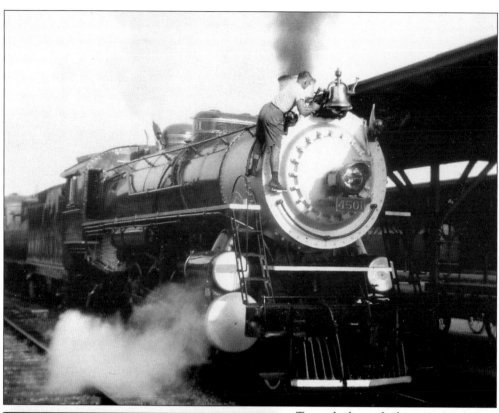

Towards the end of passenger train operations on the Southern Railway, passenger excursions were operated using former Southern Railway steam locomotives. In this very early photograph, ex-Southern Railway No. 4501, a freight locomotive built in 1911 for the Southern Railway, is seen standing at Terminal Station in the late 1960s. The man working on the locomotive's bell ringer is Robert L. Johnson of Chickamauga, Georgia. (Courtesy David H. Steinberg.)

A Southern Railway train porter stands on the platform in front of his train as it boards passengers at Terminal Station in the 1960s. Until desegregation, railway unions kept black railroaders from being promoted to the position of conductor, brakeman, or engineer. (Courtesy Chattanooga Choo Choo–David H. Steinberg.)

It is November 23, 1969, and Train No. 3 is passing Tinker Street bridge (now Wilcox Boulevard) inbound to Terminal Station. The single locomotive and three-car train are all that remain of the once great train. In just one week, the train will be permanently discontinued. (Courtesy David H. Steinberg.)

This photograph, taken in 1969, shows the area of Terminal Station and the gateman's booth near Gate No. 1. On Track 13 stands a Southern Railway train with Central of Georgia Railway's *Fort McPherson* on the rear. By 1969, the Southern Railway had purchased the Central of Georgia and was using its passenger cars in pool service. (Courtesy David H. Steinberg.)

Here Terminal Station ticket agents Hoke Buice and R.E. Pfitzer have taken a moment from their duties to pose for the photographer on August 11, 1970. That night, the *Birmingham Special* will depart Terminal Station for the final time, ending Terminal Station's days as a passenger station. (Courtesy David H. Steinberg.)

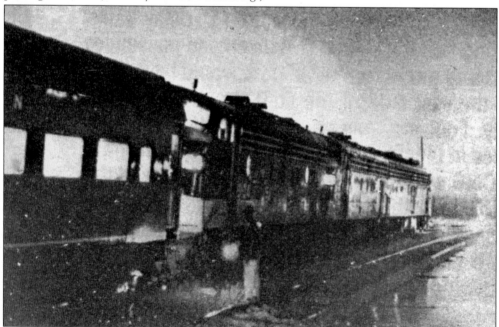

The end is at hand for Terminal Station as Train No. 18, the *Birmingham Special*, awaits its 11:35 p.m. departure for Birmingham on August 11, 1970. (Courtesy David H. Steinberg.)

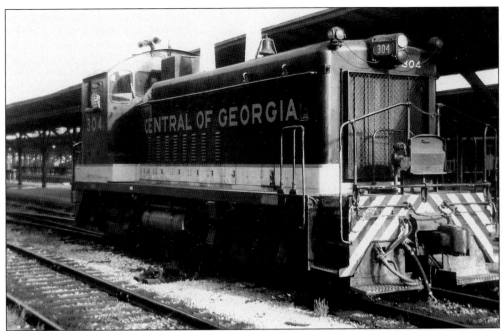

This late 1960s photograph shows Central of Georgia Railway No. 304 switching at Terminal Station. Like most railroads acquired by the Southern, the railroads operated under their own corporate names but the locomotives and rolling stock were painted in standard Southern livery. (Courtesy David H. Steinberg.)

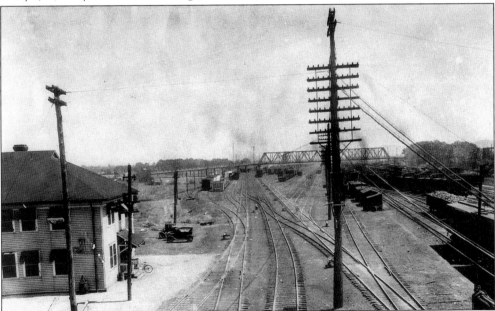

This is an early view of Citico Yards, taken in the 1920s looking south towards Third Street bridge. The building at left may be the yardmaster's office. The Third Street bridge stood until late 2002, when replacement work began. That bridge served as a photographer's platform in 1953, when the last steam train on the Southern Railway arrived in Chattanooga. (Courtesy David H. Steinberg.)

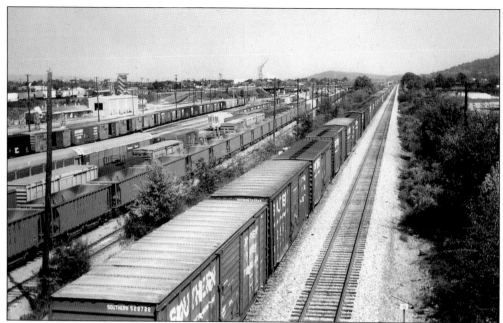

In 1954, Southern Railway opened the new Citico Yard. One major change was that the new yard used a manmade hump to speed the assembly of outbound trains. Yard operations are controlled from the main tower. The double-track main line in the foreground is the Western and Atlantic Railroad line from Chattanooga to Atlanta, now operated by CSXT. (Courtesy Tennessee Valley Railroad Museum.)

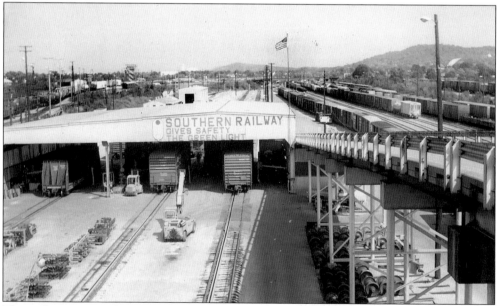

This is the car repair shop at DeButts Yard, seen in 1983. The ramp at right connected the yard service road to the Wilcox Boulevard bridge. Just to the left of the shop building, a cut of cars is being broken up for classification on the hump. Originally Citico Yard, the facility was later renamed for the late Southern Railway President Harry DeButts. (Courtesy Tennessee Valley Railroad Museum.)

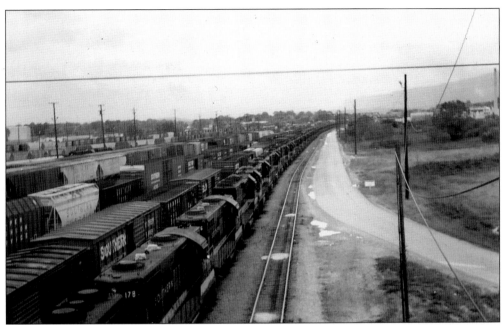

Another major facility located at DeButts Yard was the Diesel Shop. At one time, the Diesel Shop performed all sorts of work on locomotives from minor servicing to major repairs. One part of every locomotive maintenance facility was the "dead" line, seen here at Chattanooga in October 1983. There, locomotives could be found awaiting repairs or disposition. (Courtesy Tennessee Valley Railroad Museum.)

This view looking south shows East End Tower and its interlocking plant in the 1960s. This tower, built in 1947, replaced the original tower constructed in 1909. East End was a major interlocking plant, controlling the crossing of the Western and Atlantic Railroad, Southern Railway, and the East Chattanooga Belt Line. (Courtesy David H. Steinberg.)

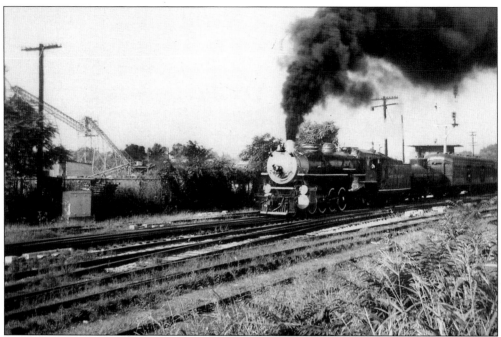

Chattanooga was one of the principal cities on the Southern Railway Excursion Program in the late 1960s. Here, an eastbound excursion train pulled by ex-Southern Railway No. 4501 passes East End on its way out of town. (Courtesy David H. Steinberg.)

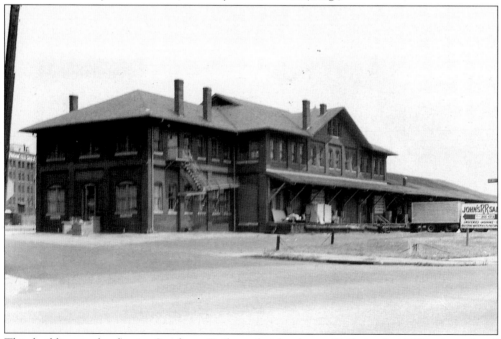

This building is the former Southern Railway freight depot. Built in the 1880s, it replaced the former freight depot that had been rebuilt as Central Depot. By the time this photograph was taken in the 1960s, it was being used by John's Railroad Salvage. (Courtesy David H. Steinberg.)

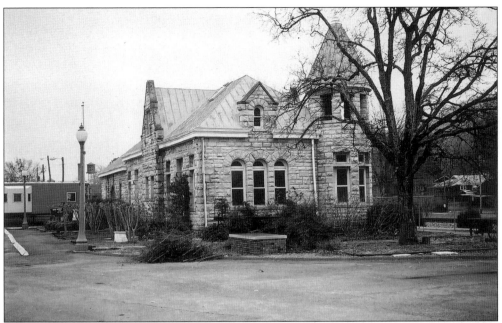

This building, constructed in the early 1890s, is the Alabama Great Southern Railway depot at Fort Payne, Alabama. This railroad, started in the late 1850s as the Wills Valley Railroad, was not completed until 1871. Known as the Alabama and Chattanooga Railroad, it was taken over in 1877 by the State of Alabama and later reorganized as the Alabama Great Southern Railway. (From the author's collection.)

Seen here in December 1982, this freight depot is located on the Cincinnati, New Orleans and Texas Pacific Railway at Dayton, Tennessee. Completed in 1880, the Cincinnati Southern Railway was the first direct rail link between major Northern and Southern cities. This line was built by the City of Cincinnati and leased to the Cincinnati, New Orleans and Texas Pacific Railway. (Courtesy Tennessee Valley Railroad Museum.)

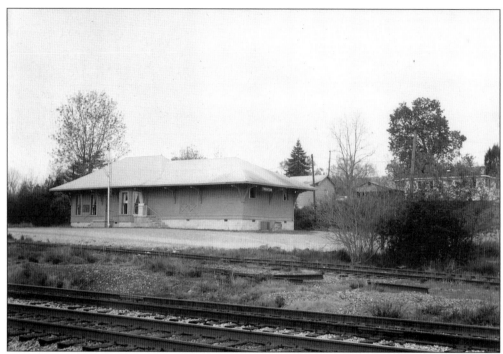

This is the Alabama Great Southern Railway depot at Trenton, Georgia. At the time of the Civil War, the Wills Valley Railroad was completed only to this point. Following the end of the war, the Alabama and Chattanooga Railroad took over the line, completing it to Meridian, Mississippi, in 1871. (Courtesy Tennessee Valley Railroad Museum.)

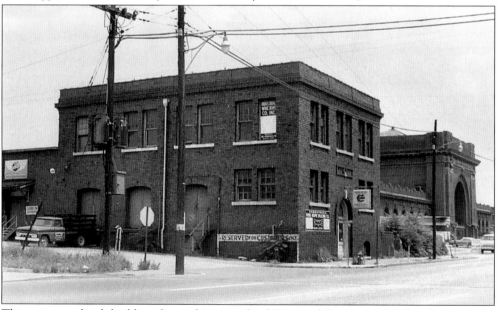

This two-story brick building, located just north of Terminal Station on Market Street, is the Central of Georgia Railway freight depot. By the time this photograph was taken in the late 1960s, the Industrial Wire Rope Supply Company was using the building. (Courtesy David H. Steinberg.)

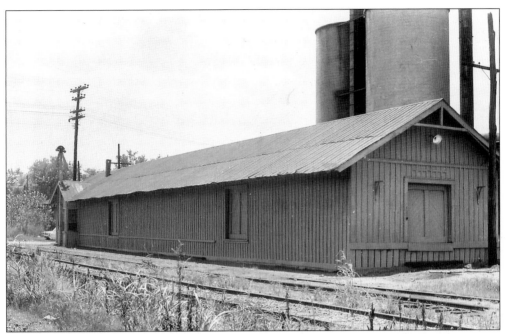

This depot is located in the town of Rossville, Georgia, which is just below the Tennessee-Georgia state line. The building never had passenger facilities, as all passenger service on the Chattanooga-Griffin line had ended prior to its construction. (Courtesy David H. Steinberg.)

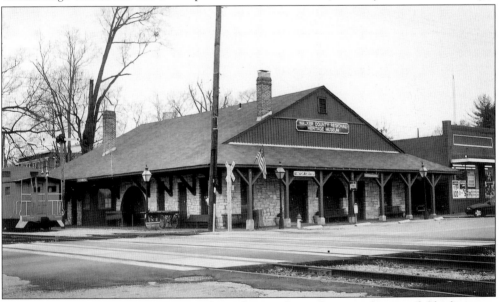

Crawfish Springs, Georgia, was an early settlement located on a tributary of Chickamauga Creek. Development of the town, later renamed Chickamauga, was primarily due to the Lee and Gordon's Mill and tourism generated by the Chickamauga and Chattanooga National Military Park, established in the 1890s. This depot, built in the late 1880s, is now home to the Walker County Regional Heritage Museum. It is used as a passenger stop by all Tennessee Valley Railroad Museum trains that operate on that line, though regular passenger service ended on the line in December 1950. (From the author's collection.)

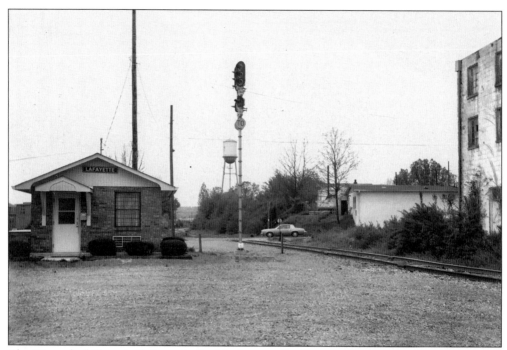

The Central of Georgia Railway built this depot at La Fayette, Georgia, in the 1950s. It had only space for a freight agent's office, as passenger service was discontinued by the time it was constructed. This depot was removed in the late 1980s and replaced by the present structure. (Courtesy Tennessee Valley Railroad Museum.)

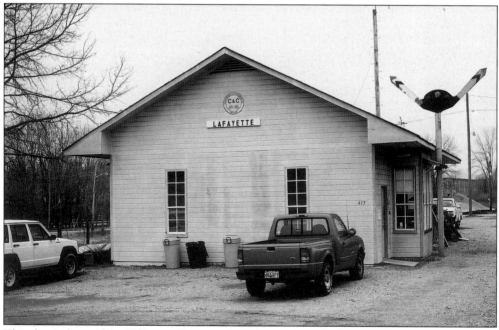

This depot, located on Villanow Street in La Fayette, Georgia, replaced the 1950s Central of Georgia depot. The Chattooga and Chickamauga Railway built the depot, and it serves as a yard office. (From the author's collection.)

This wood frame depot served the citizens of Summerville, Georgia, as well as the town of Trion after that depot burned sometime prior to the end of passenger service in 1950. Now the depot is used by the local historical society. Presently there is no commercial freight service on this part of the railroad, but occasional excursion trains are operated to that point by the Tennessee Valley Railroad Museum. (From the author's collection.)

This building is believed to be part of the Georgia Avenue depot of the Chattanooga Southern Railway. It was built in 1890 on the site of the present-day Joel Solomon Federal Building and later served the Tennessee, Alabama and Georgia Railway and the Chattanooga Union Railway. (Courtesy David H. Steinberg.)

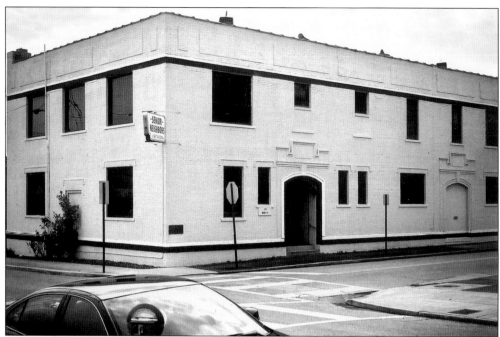

This structure is the former Tennessee, Alabama and Georgia Railway corporate offices and freight depot at the corner of Newby and Eleventh Streets. It was built in the 1920s and eventually replaced the Georgia Avenue depot when that property was sold by the State of Georgia to the U.S. government (the Joel Solomon Federal Building now occupies that site). In the 1960s, this building was donated by the railroad to the Senior Neighbors of Chattanooga. (From the author's collection.)

The Tennessee, Alabama and Georgia Railway's engine terminal was located in their Alton Park Yards in south Chattanooga. This photograph was taken c. 1900, when the railroad was experiencing severe financial difficulties. (Courtesy David H. Steinberg.)

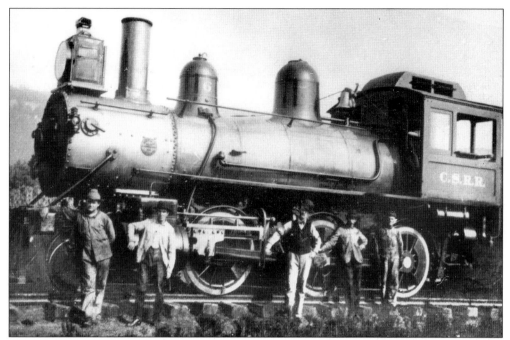

This Chattanooga Southern Railway crew has stopped somewhere in the Chattanooga Valley to pose with their brand-new Mogul-type locomotive, Chattanooga Southern No. 6, which was built by Cooke in 1895. Lookout Mountain is seen in the background. (Courtesy David H. Steinberg.)

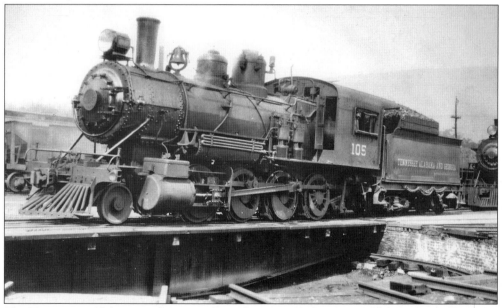

The Tennessee, Alabama and Georgia (TAG) No. 105 is being run onto the turntable at the Alton Park roundhouse in this 1920s photograph. The No. 105 was built by the Rhode Island Locomotive Works and was the first of three similar machines acquired by the TAG secondhand from the Louisville and Nashville Railroad between July 1929 and May 1930. (Courtesy David H. Steinberg.)

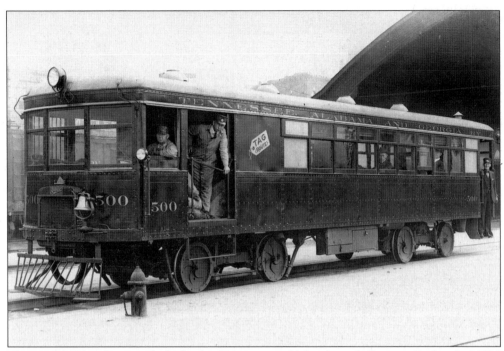

This mid-1920s photograph finds the Tennessee, Alabama and Georgia Railway's M500 awaiting departure time at Union Depot. By 1922, passenger traffic on the TAG Route had dropped to the point that the railroad company replaced their passenger trains with two Brill M55 motorcars, M500 and M501. (Courtesy David H. Steinberg.)

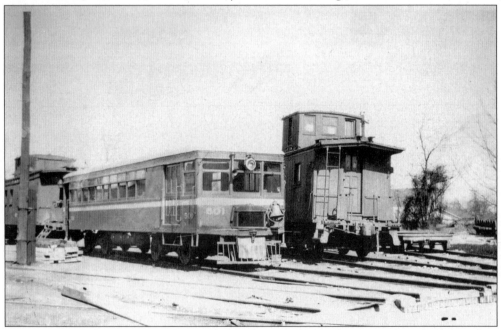

The TAG Railway's second Brill motorcar, M501, is parked adjacent to the caboose track at Alton Park. This car was used to provide the last passenger service on the Tennessee, Alabama and Georgia Railway on January 31, 1951. (Courtesy David H. Steinberg.)

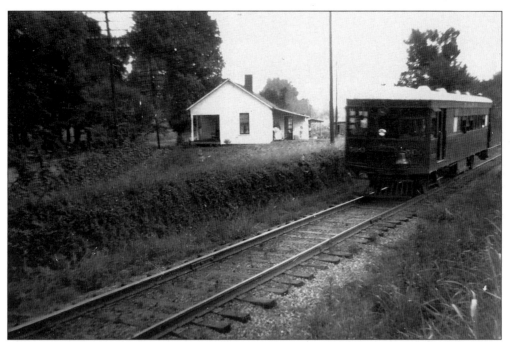

The TAG M500 passes through the Chattanooga Valley near Flintstone, Georgia. Most of the line passed through rural farmland and the railroad had no online industries to speak of. That would prove to be fatal to the railroad in the end. (Courtesy David H. Steinberg.)

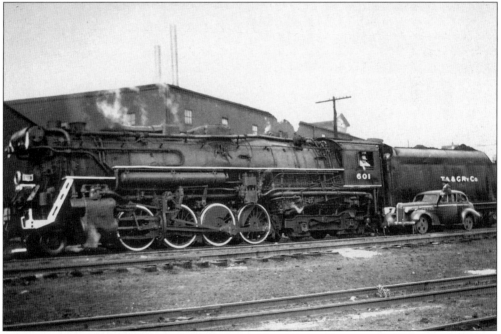

In 1950, steam on the TAG was in its last year. No. 601 (ex-Boston and Albany No. 1423) is pictured with a 1936 Oldsmobile inspection car pulled alongside in the Alton Park yard. The two TAG Berkshire locomotives were the only ones of their type to operate in the Tennessee Valley. (Courtesy David H. Steinberg.)

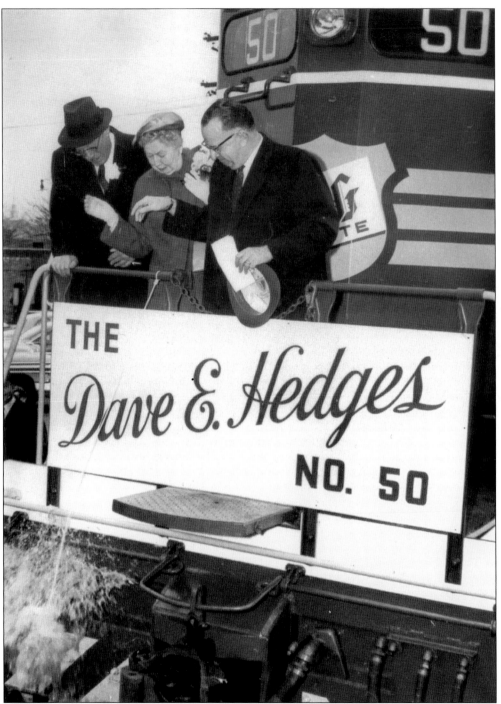

On February 27, 1960, the Tennessee, Alabama and Georgia Railway honored then President D.E. Hedges. In this photograph, Mr. and Mrs. Hedges (left and center) are joined by Garrison Siskin, chairman of the TAG Board of Directors, and have just christened locomotive No. 50, a GP-18, with a half-gallon bottle of cider from an orchard owned by the Hedges on Walden's Ridge. (Courtesy TAG Railway Historical Society.)

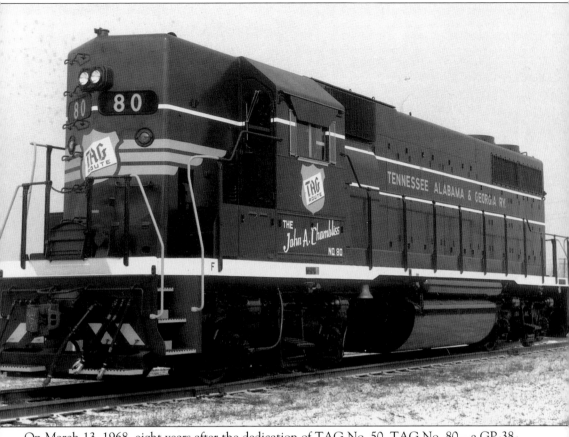

On March 13, 1968, eight years after the dedication of TAG No. 50, TAG No. 80—a GP-38-2—was dedicated at Terminal Station for prominent Chattanooga attorney John A. Chambliss, who had served as general counsel to the railroad since 1928 and later became a board member and executive vice president. (Courtesy TAG Railway Historical Society.)

A modern TAG caboose and cars in the Alton Park yard are seen here in the 1960s. The building on the left is the yardmaster's office. The two bay building to the right of the yardmaster's office are the diesel engine house. In the TAG's final years, the freight agent's office was also located here. These buildings were dismantled in the early 1970s. (Courtesy David H. Steinberg.)

In this second view, the engine house is better seen. One of the TAG's locomotives, either a GP-7 or their lone GP-18, is standing just outside the building. (Courtesy David H. Steinberg.)

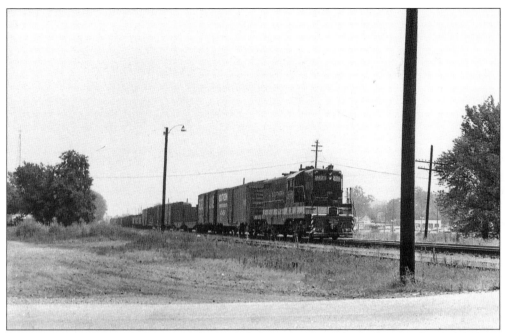

In 1970, the TAG was sold to Southern Railway Systems by the Siskin family. A Southern Railway freight on the TAG is seen near Alton Park. (Courtesy David H. Steinberg.)

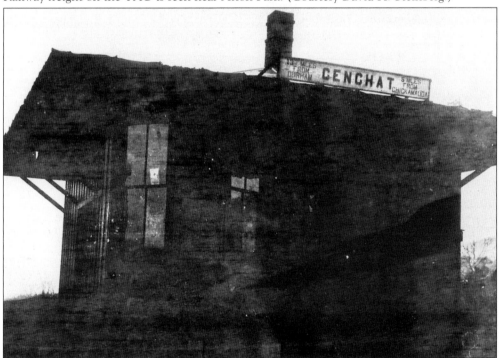

At Cenchat, Georgia, the TAG crossed the line of the Chattanooga and Durham Railroad. That line ran from Durham, Georgia, on top of Lookout Mountain to the coke ovens at Chickamauga, Georgia. It was used to bring coal from the mines at Durham. The line was pulled up in the 1950s. (Courtesy David H. Steinberg.)

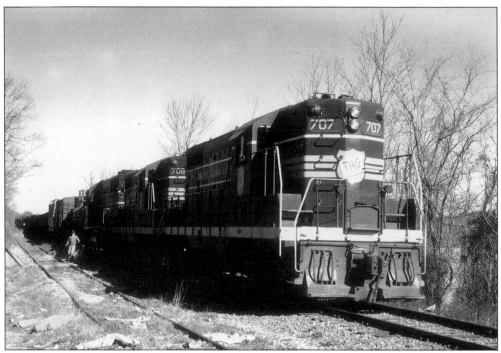

Seen here in the late 1960s, a TAG freight is switching cars at Cenchat. The locomotives consist of GP-7s Nos. 707, 708, and GP-38 No. 50—the *John A. Chambliss*. (Courtesy David H. Steinberg.)

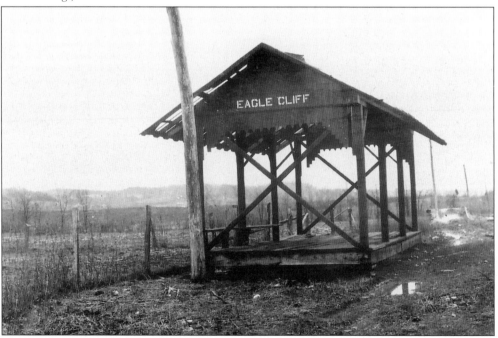

The TAG's modest freight platform at Eagle Cliff, Georgia, was most likely a prepaid freight station and is a good example of the most basic freight building on any railroad. (Courtesy David H. Steinberg.)

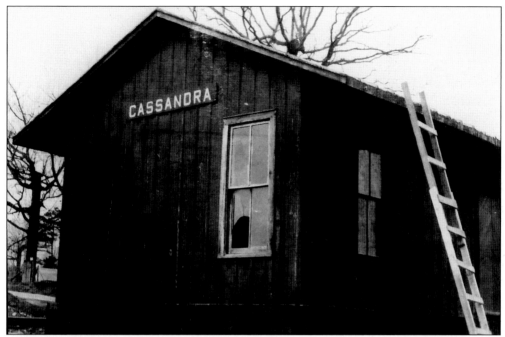

Cassandra, Georgia, was another freight station on the TAG Route. This building was somewhat more elaborate, containing an agent's office and enclosed freight area. (Courtesy David H. Steinberg.)

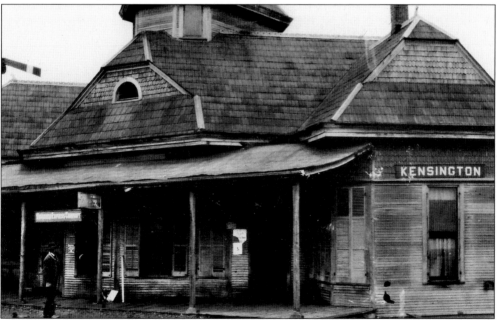

Kensington, Georgia, was one of the few sizable towns on the TAG Route. Originally envisioned to be developed as a resort town, it justified a larger depot, complete with passenger facilities and an express office. Its somewhat weathered condition reflects the tough financial spot the railroad was in at the time that the photograph was taken, around the turn of the century. This building burned in 1932 and was never rebuilt. (Courtesy David H. Steinberg.)

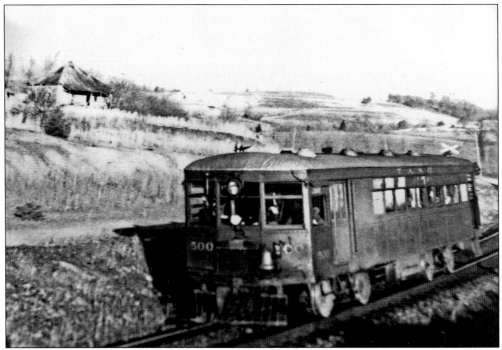

Here, an M500 traverses Kensington Curve on its way to Gadsden, Alabama. Once at Gadsden, the car will turn and make the return trip to Chattanooga. (Courtesy David H. Steinberg.)

This depot was the western terminus of the TAG Route at Gadsden, Alabama. Gadsden was served by the TAG, Southern Railway, and the Nashville, Chattanooga and St. Louis Railway. (Courtesy David H. Steinberg.)

# Five

# RAPID TRANSIT IN THE SCENIC CITY

## STREET RAILWAYS, INTERURBAN RAILWAYS, AND INCLINES

With increasing industrial development and the growth of the residential areas away from the downtown district south of Ross's Landing, the need for a street railway became increasingly apparent. The emerging street railways did not have an easy time establishing themselves, as there were often disputes among themselves and occasionally the major steam railroads, all of which were competing for the business of the commuter and tourist.

The first mention of a street railway in Chattanooga appeared in 1867, when the Tennessee legislature was approached by a group of Chattanooga businessmen wanting to secure a charter to operate a rail line down the length of Market Street. Financial hard times prevented raising sufficient capital to finance this undertaking. In 1872 the Chattanooga and Lookout Street Railroad Company was chartered. Reorganized as the Chattanooga Street Railroad Company, it completed its line along the length of Market Street commencing operation on September 4, 1875, employing one horse car for operations. The line would operate two additional cars. Unfortunately, the line was soon run into the ground by the reckless management of its first manager, A.J. "Fatty" Harris, who was quite a colorful character. Harris did not get the honor of driving the ceremonial first horse car or even riding it. This was due to the simple fact that his physical size prevented him from fitting on the car's platform, much less inside the car. Fatty's drinking only made the brief story of the line more interesting. It was reputed that he would sit in a large chair at J.W. Kelly's saloon, and as each car passed, he would count the passengers. If there were as much as 15¢ in passenger fares represented, he would take a drink! In short order, the line was liquidated and the wreckage of the line picked up by other businessmen in the late 1870s.

In 1881, the Chattanooga Street Railroad was acquired by J.H. Warner and his associates. Having had experience operating street railroads in other cities, Warner was able to quickly put the line back into proper operating condition, restoring public faith in the line and patronage. In July 1881, the new company began to extend the line south, hoping to eventually reach the foot of Lookout Mountain. In 1888, competition appeared in the form of the Chattanooga Electric Street Railway, the first electric line in the city. This line commenced operations on June 22, 1889. It very quickly began to expand, opening the Missionary Ridge line on July 15, 1889, and absorbing the Chattanooga Street Railroad Company on July 27 of that same year. Replacement of horse cars began immediately, but total elimination of horse cars was not achieved until August 11, 1891. While the mules were sold off, the cars themselves were

retained. Some cars were electrified for use on lines with low levels of traffic, and others were spliced together to create larger cars.

While much of the development of commuter service involved trolley cars, there were also steam dummy railroad operations in the city. They were operated by the Chattanooga Union Railway, which was built in March 1885 to provide for the transfer of freight cars between local industries and the yards of the major steam railroads. The potential of the line as a passenger carrier did not escape the attention of the line's officers. In mid-1886, they announced the line would construct a route from downtown to Highland Park and Ridgedale and that the Union Railway would commence passenger operations. The new line was opened on October 16, 1886. Further extensions included a route that served East Chattanooga/Sherman Heights and extended eventually as far as the Boyce depot, near present-day Stuart Street. This line would come under the control of the Alabama Great Southern Railway, which purchased it in 1895.

In 1896, the Rapid Transit Company acquired a lease on the line, and by 1898, improvements were begun. The changes included the introduction of electric trolleys, extension to the Chickamauga and Chattanooga National Military Park via the Chattanooga, Rome and Columbus Railroad, and the acquisition of the Chattanooga and North Side Railway Company and the rail operations on the north end of Lookout Mountain in 1900.

The Chattanooga and Lookout Mountain Railway, known as the Broad Gauge, had been completed in 1888. Another line, the Mount Lookout Railway, which was known as the Narrow Gauge, had been built in 1885 to connect the Point Hotel with Sunset Rock and Natural Bridge, two major sites visited by tourists at that time. The fatal flaw of both railroads was that they depended too heavily on the hotels to generate tourist passenger business. Both lines were shut down by 1900.

The consolidation of the Chattanooga Electric Street Railway and the Rapid Transit Company into the Chattanooga Railways Company occurred on March 19, 1906. In 1909, this company merged with the Chattanooga Electric Light Company, creating the Chattanooga Railway and Light Company. In 1913, the Chattanooga Railway and Light Company commenced electric car operation between downtown Chattanooga and the top of Lookout Mountain, utilizing the old right of way of the Chattanooga and Lookout Mountain Railway. These electric car operations faced financial failure for the same reasons that doomed the Chattanooga and Lookout Mountain Railway. Although regular service was discontinued in 1920, temporary service was offered whenever the Incline Railway was shut down for repairs. This service continued until 1924, though the mountaintop car service continued until August 28, 1928.

The only commercially successful rail lines on Lookout Mountain were Incline No. 1 and Incline No. 2. In 1887, Incline No. 1 was completed to serve the Point Hotel, where it connected with the Narrow Gauge railroad. It followed a gentle grade up the mountain and had two major curves, almost unheard of on a funicular railroad. It operated until Incline No. 2 was opened by the Lookout Incline and Lula Lake Railway in 1895. Incline No. 1 was dismantled in 1900 after plans to use it exclusively for freight service failed to develop.

Incline No. 2 was intended to be a more direct link between the street railway lines at the foot of the mountain and the Lookout Inn, the major competitor to the Point Hotel. This line ascended the mountain with a grade of 72.7 degrees, making it the steepest passenger incline in the world. Service on the line was interrupted twice, both times by nighttime fires that exacted heavy damage to the line. The first fire occurred on December 13, 1896, and the second on March 24, 1919. Both fires destroyed the powerhouse, the upper station, and the car stored there. In both cases, repairs were immediately made and the line was restored as quickly as possible, with trolley service from Chattanooga being offered in the interim. Even after the demise of both the Lookout Inn and Point Hotel, the Incline continued to thrive, as it served both mountain residents and tourists alike. The line continues to operate, now part of the Chattanooga Area Regional Transportation Authority, and is the transportation authority's biggest moneymaker, carrying more than 100,000 passengers annually.

The last great building project undertaken by an electric railroad in Chattanooga was the construction of the Chattanooga Traction Company. This line was organized by Charles E. James in 1911 with the intention to connect Signal Mountain, Tennessee, to Chattanooga. This was necessary to allow James to develop his mountaintop property as a successful resort hotel, the Signal Mountain Inn. On June 8, 1913, the Signal Mountain Inn was opened to the public. Construction started at the line's North Chattanooga connection with the Chattanooga Railway and Light Company four days later, and by the second week of August, the line was completed to the Glendale station. Service was provided by the Chattanooga Railway and Light Company, as the large Brill interurban cars ordered for the Chattanooga Traction Company did not start arriving until that September, when the line was completed to James Point. The line reached the hotel in October 1913, and it proved to be the only financially viable mountain rail line, other than the two Lookout Mountain inclines. It operated until July 4, 1934, when it was replaced with bus service.

Chattanooga Traction Company also operated passenger service on its Dry Valley Line, completed to Red Bank, Tennessee, in 1915. Passenger service was not started until 1917 as copper wire and additional electric cars were not available until that time. Freight service was offered on all lines, with cars being transferred via car float from the Nashville, Chattanooga and St. Louis Railway's Craven's Yard. This continued until a connection with the Cincinnati, New Orleans and Texas Pacific Railway was completed between Tenbridge, just north of the Tennessee River bridge, and C and D Junction on the Dry Valley Line. During the replacement of the Tennessee River Bridge, from August 1919 until January 1920, all utilized a temporary station constructed at the end of the Chattanooga Traction Company's line in North Chattanooga. Passenger service on the Dry Valley Line ended in 1928. With the end of the Signal Mountain line, the company's freight operations were taken over by the Cincinnati, New Orleans and Texas Pacific Railway in late 1934. The electric steeplejack switchers served until April 19, 1941, when they were replaced by diesel electric switchers. The railroad itself operated as an independent subsidiary of the Cincinnati, New Orleans and Texas Pacific Railway until September 1969, when it was fully absorbed into that company.

As for the Chattanooga Railway and Light Company, it met its end in 1920 when it was taken over by the Tennessee Electric Power Company (TEPCO). This was the beginning of the end for the Chattanooga streetcars, as the company announced that no new streetcar lines would be constructed. Although failing lines were abandoned, existing service was continued with improvements to lines that were profitable. Abandonment of money-losing car lines started almost immediately and was continued by the Tennessee Utilities Corporation, and later Southern Coach Lines, both successors of TEPCO. On April 9, 1947, the Boyce line discontinued, and with that, the end of an era had arrived in Chattanooga.

The end of electric traction in the Tennessee Valley did not come until November 1964. The Tennessee Electric Power Company built a line from the Nashville, Chattanooga and St. Louis Railway at Ladds, Tennessee, to Guild, a distance of 3 miles. This line was built to allow the company to improve the power-generating station at its Hales Bar Dam with a steam-generating plant. The line utilized a freight motor that was built using the frame and partial body of electric car No. 292, formerly a Chattanooga streetcar. Rebuilt and re-motored, it served from 1923 to 1964, used for construction and hauling coal to the plant. By the 1960s, it was apparent that the Hales Bar Dam would have to be replaced and the Tennessee Valley Authority commenced building the Nickajack Dam 6.5 miles downstream. Its usefulness outlived, the Hales Bar electric line was removed, as the area was to be flooded. The freight motor was donated by the Tennessee Valley Authority to the Tennessee Valley Railroad Museum on November 9, 1964. Sadly, the car was scrapped afterwards and a unique piece of Tennessee Valley railroad history was lost forever.

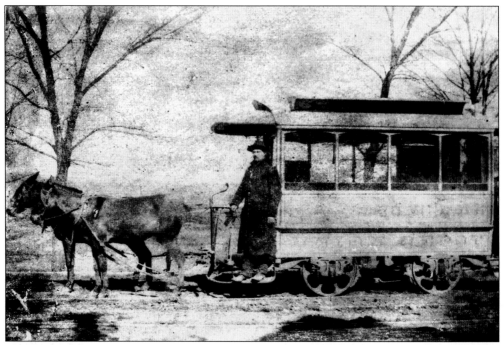

This mule-drawn horse car ran on Chattanooga Street Railway's East Side Lines, extended in May 1887. Here it is seen at the location of Vine and Douglas Streets. (Courtesy David H. Steinberg.)

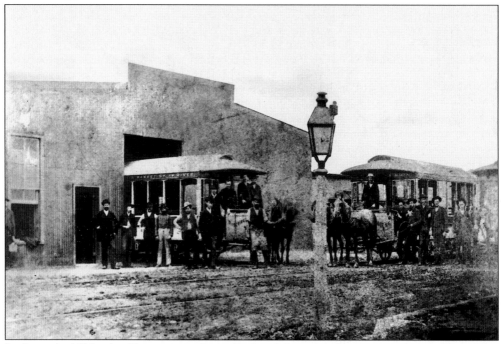

In the early 1880s, the Chattanooga Street Railroad Company began extending its lines. This early photograph shows the company's car barn, the location believed to be at White and Whiteside Streets. (Courtesy David H. Steinberg.)

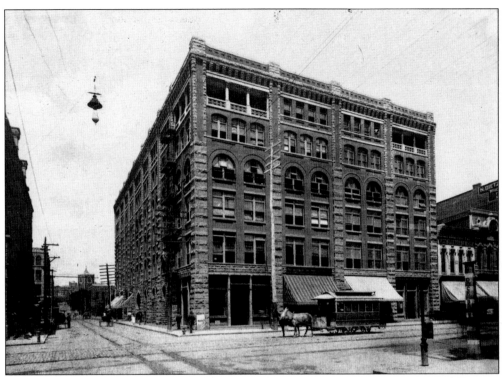

Above, a Chattanooga Street Railroad horse car passes in front of the Richardson Building, now the site of the former Miller's Department Store. The street railroad line crossing Market Street along Seventh Street in this 1890s view is the Chattanooga Electric Street Railroad Company. (Courtesy David H. Steinberg.)

This map illustrates the extent of Chattanooga's horse car lines as of 1890. Despite the introduction of steam and electric transit lines in 1887 and 1888, horse cars hung on until August 11, 1891. (Courtesy David H. Steinberg.)

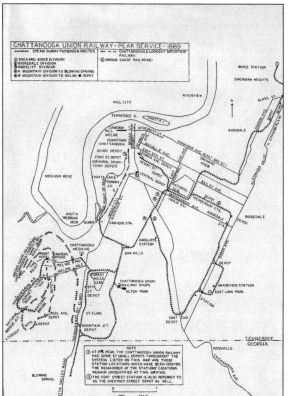

This map illustrates the lines operated by C.E. James and his Chattanooga Union Railway in 1889. The properties of this company would eventually be divided between the Alabama Great Southern Railway and the Tennessee, Alabama and Georgia Railway. (Courtesy David H. Steinberg.)

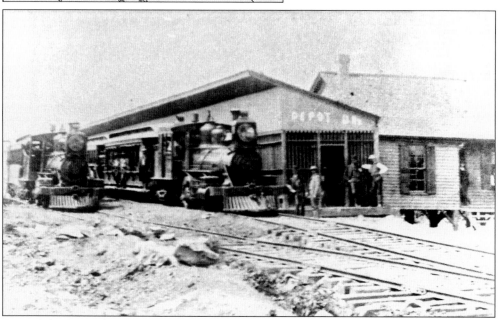

One of the first railroads to provide commuter service in Chattanooga was the Chattanooga Union Railway. These two trains are standing at the railway's Newby Street depot preparing to depart for East Lake and Sherman Heights. The railroad used Forney-type locomotives and steam dummies to power their passenger trains. (Courtesy David H. Steinberg.)

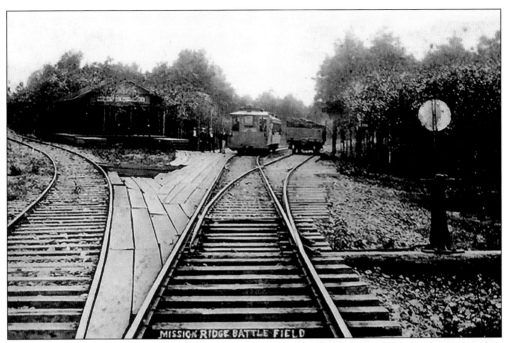

In this *c.* 1898 photograph, a Belt Line steam dummy is seen at the Chattanooga, Rome and Columbus Railroad's Mission Ridge Battlefield Station. By this time, Sam Divine's Rapid Transit Company controlled the Chattanooga Belt Railway. (Courtesy David H. Steinberg.)

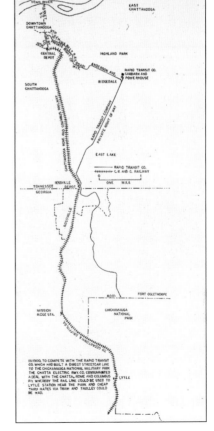

This map illustrates the routes taken by the lines that served the Chickamauga and Chattanooga National Military Park. Though the Rapid Transit Company originally used the Chattanooga, Rome and Columbus line to serve the park, the Rapid Transit opened its own line to the park at the end of January 1900. (Courtesy David H. Steinberg.)

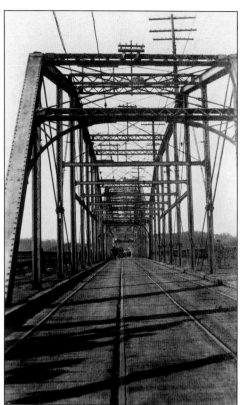

From 1867 to 1891, all traffic crossing the Tennessee River between Chattanooga and Hill City was transported by ferry. With the opening of the County Bridge in 1891, the North Shore and Hill City were wide open for the establishment of new streetcar lines. (Courtesy David H. Steinberg.)

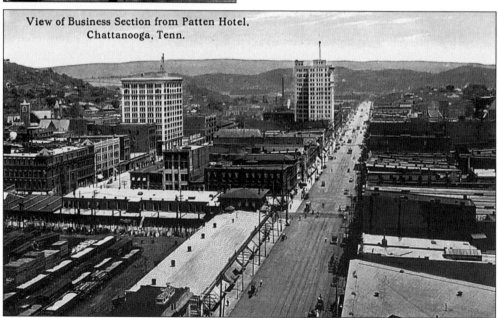

View of Business Section from Patten Hotel, Chattanooga, Tenn.

The turn-of-the-century view in this Read House Cigar Company postcard, shown from the Patten Hotel, provides a bird's-eye view of the railroad and street railway traffic at Ninth and Market Streets. The buildings at lower left are the old W&A depot and the Union Depot warehouses. (From the author's collection.)

This map shows the routes served by the Chattanooga Electric Railway Company and the Rapid Transit Railway of Chattanooga in their last year of competition. They would be consolidated as the Chattanooga Railways Company within a year. (Courtesy David H. Steinberg.)

It's summertime in the Tennessee Valley in this turn-of-the-century view. A crowded Chattanooga Electric Railway summer car passes the Loomis and Hart Manufacturing Company's plant on Ninth Street. (Courtesy David H. Steinberg.)

In 1909, the Chattanooga Electric Light Company and the Chattanooga Railways Company were merged, creating the Chattanooga Railway and Light Company (CR&L). The cover of the CR&L's 1913 advertising brochure promoted the company's trolley lines as the way to see the area's historic Civil War sites. (From the author's collection.)

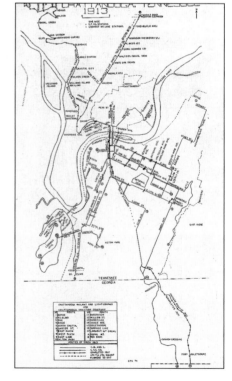

This map shows the Chattanooga streetcar routes at their peak in 1913. That year, the last great trolley lines were completed. In 1920, the Tennessee Electric Power Company took control of the Chattanooga Railway and Light, ending any possibility of new construction of trolley lines. (Courtesy David H. Steinberg.)

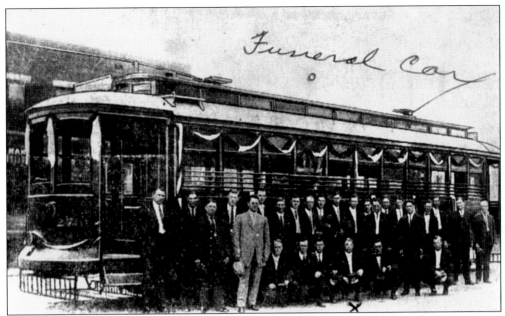

The somber group posing in front of Chattanooga Railway and Light Car No. 276 is a group of conductors and motormen who have just attended the funeral of "Doc" Hearn, one of the company's first motormen. This photograph was taken in 1913. (Courtesy David H. Steinberg.)

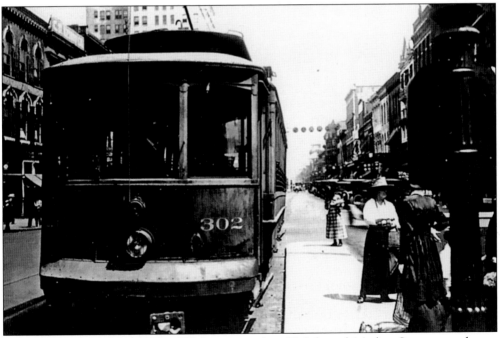

A northbound CR&L car No. 302 has stopped at Eighth and Market Streets to take on passengers in this 1920s photograph. The safety islands seen here remained until 1947. (Courtesy David H. Steinberg.)

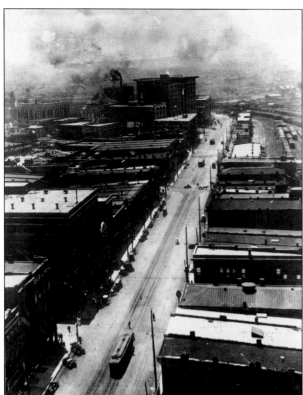

This view illustrates the congestion facing the city in the early 1920s. Until 1926, the only major north-south thoroughfare below Ninth Street was Market Street. The large building at the curve in Market Street is the Patten Hotel. (Courtesy David H. Steinberg.)

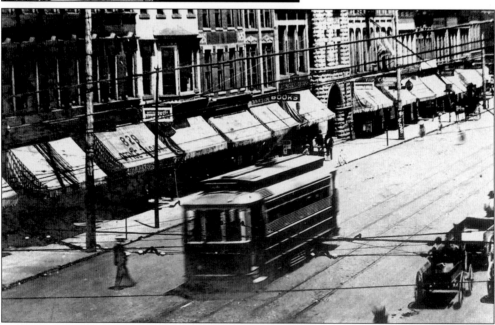

During the first two decades of the 20th century, the greatest dangers presented to Chattanooga pedestrians were the streetcar and horse-drawn wagon. Automobiles did not start appearing in large numbers until around 1915 or 1920. The line shown here is most likely that to North Chattanooga along Market Street. (Courtesy David H. Steinberg.)

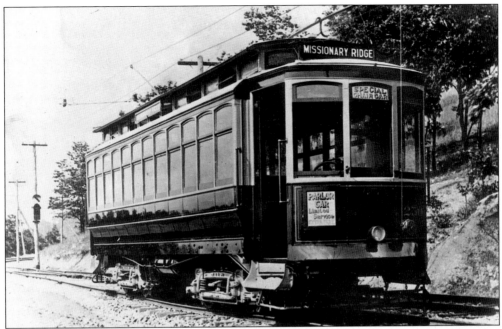

Not all service provided by Chattanooga Railway and Light was the same. One special service offered was weekday parlor car service on the Missionary Ridge line. This was operated by Car No. 250, which was a special car outfitted with white interior carpeting, swivel chairs with individual electric fans, and a card table at the rear. This car was used for charter work on weekends. (Courtesy David H. Steinberg.)

This Read House Cigar Company postcard shows the reason for the extension of the Chattanooga Traction Company to Signal Mountain by Charlie James. It was needed to provide convenient transportation to his new Signal Mountain Inn. After hotel operations ceased, it became the assisted-living apartments in the Alexian Brothers assisted-living and nursing home facility. (From the author's collection.)

The last major streetcar line to be constructed in the Chattanooga area was the Chattanooga Traction Company's Signal Mountain line. Because of the traffic to and from the Signal Mountain Inn, this line was operated with large single- and double-ended Brill interurban cars. This c. 1920 view shows one of the single-end Brill cars headed up the mountain. (Courtesy David H. Steinberg.)

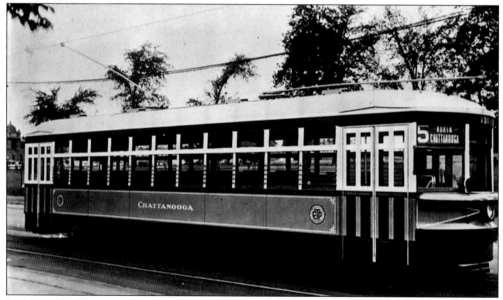

In 1922, the Tennessee Electric Power Company (TEPCO) assumed operation of the former Chattanooga Railway and Light system. Car Nos. 131–140 were built by the St. Paul Car Company in 1926 and carried individual names. This c. 1930 photograph shows Car No. 131, the Chattanooga. (Courtesy David H. Steinberg.)

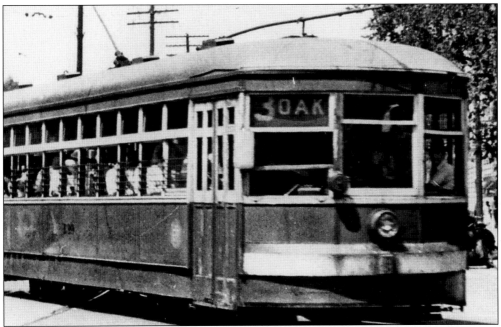

One of the last car lines to operate in Chattanooga was the Oak Street line. Car No. 139 is seen here working. Service on this line ended on September 14, 1946. (Courtesy David H. Steinberg.)

One of the more unusual electric railways to operate in the Chattanooga area was the Tennessee Electric Power Company line that served the Hales Bar Dam at Guild, Tennessee. The freight motor employed there was a homebuilt machine, rebuilt from the remains of a Chattanooga streetcar. This line was abandoned in 1965. (Courtesy David H. Steinberg.)

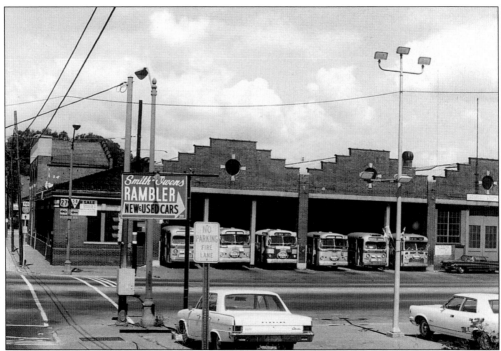

This building is the 1906 Chattanooga Railways Company car barn on North Market Street. By the time this photograph was taken in the 1960s, the building was being used by Southern Coach Company to store their city buses. This building is now used by stores and restaurants. (Courtesy David H. Steinberg.)

This building served for many years as the engine house of the Chattanooga Traction Company. Its importance declined once the Southern Railway replaced its electric motors with diesel electric locomotives. The structure was eventually removed. (Courtesy David H. Steinberg.)

This building located in North Chattanooga is the yard office of the Chattanooga Traction Company. Traction company locomotives and their crews were based out of North Chattanooga, while all other Southern Railway crews were based out of Citico Yards. (Courtesy David H. Steinberg.)

The Chattanooga Traction Company No. 4, an SW-1 locomotive, is sitting in front of the engine house at North Chattanooga c. 1960. Up until April 1941, all operations on the Chattanooga Traction Company lines were done with electric steeplejack freight motors. (Courtesy David H. Steinberg.)

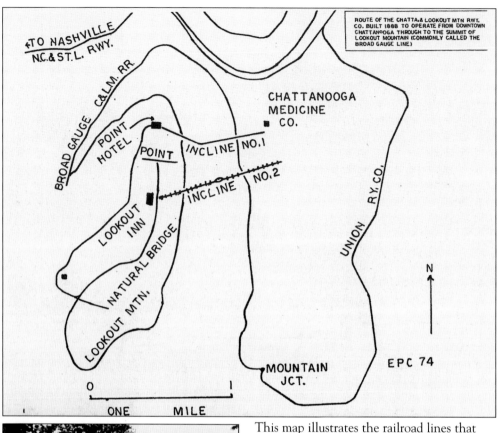

← TO NASHVILLE
N.C.& ST.L. RWY.

BROAD GAUGE C&L.M. RR.

POINT HOTEL

CHATTANOOGA MEDICINE CO.

POINT

INCLINE NO.1

INCLINE NO.2

LOOKOUT INN

NATURAL BRIDGE

LOOKOUT MTN.

UNION R.Y. CO.

N ↑

EPC 74

MOUNTAIN JCT.

0        1

ONE        MILE

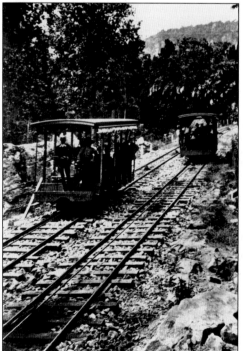

This map illustrates the railroad lines that served the Tennessee side of Lookout Mountain. The popularity of the mountain as a tourist attraction led to the sale of property for commercial use in the 1880s. Two such developments were the Lookout Inn and the Point Hotel, both built in 1887–1888. These establishments were served by the Chattanooga and Lookout Mountain Railway and Incline No. 1, respectively. (Courtesy David H. Steinberg.)

This late-1880s view shows the two cars of Incline No. 1 passing at the halfway point. Just beyond the car on the right, one of the line's two curves can be seen. (Courtesy David H. Steinberg.)

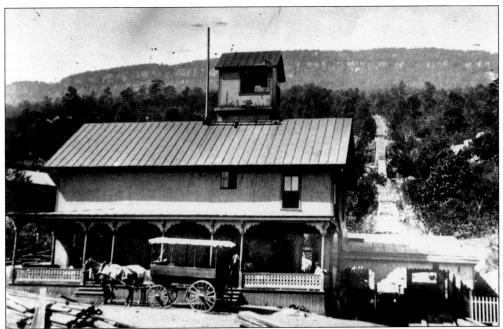

This building, constructed in 1886 at the site of present-day Thirty-Eighth and Church Streets, was the base station of Incline No. 1. The right of way from the base station to the first curve can be seen in the distance. Operation of the line ceased in 1899. (Courtesy David H. Steinberg.)

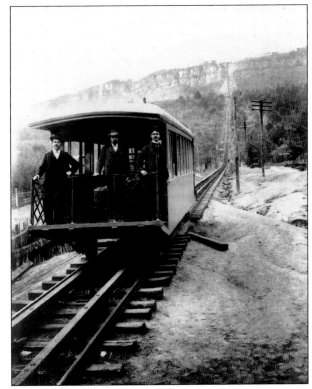

This c. 1895 view of Incline No. 2 shows a car heading up the mountain from the St. Elmo station. Though the cars and equipment have changed over the years, this line was and still is the steepest passenger incline in the world. (Courtesy David H. Steinberg.)

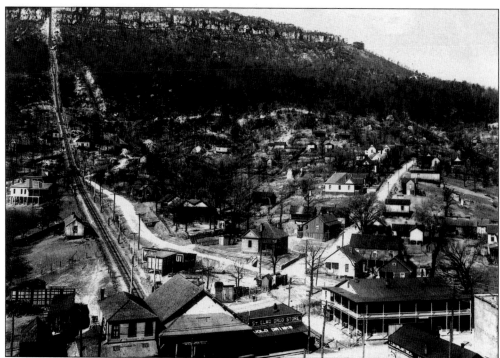

This c. 1913 view shows the base station of Incline No. 2 and Cemetery Station of the Chattanooga Railway and Light Company. The building just below the point of the mountain is the Point Hotel, once the upper station of Incline No. 1. (Courtesy David H. Steinberg.)

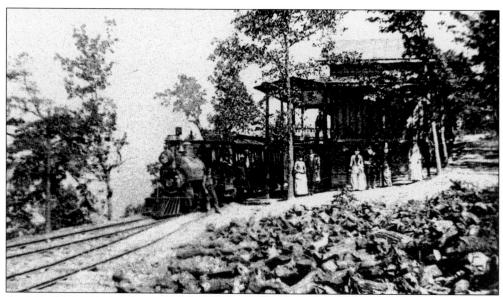

A train on the narrow-gauge incline railroad, also known as the Mount Lookout Railway, stands at the line's Sunset Rock station in the late 1880s. The line was completed in 1887 by the developers of Incline No. 1 and the Point Hotel. The line provided service between the Point Hotel and Sunset Rock with service to Lookout Inn via Natural Bridge added in the 1890s. The line was abandoned in 1899. (Courtesy David H. Steinberg.)

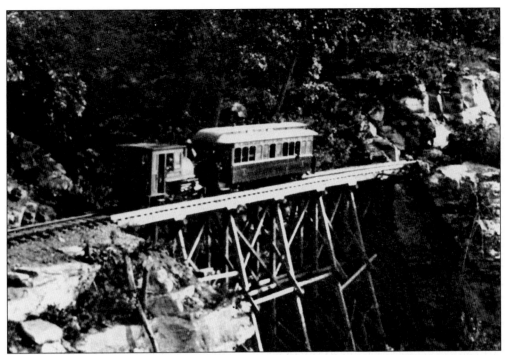

In 1887, one of the railroad lines to be built on Lookout Mountain was a narrow-gauge line. It connected the Point Hotel to Sunset Rock and other natural tourist attractions on the mountain using small saddle tank locomotives. Here the train crosses Trestle B, heading back to the hotel. (Courtesy David H. Steinberg.)

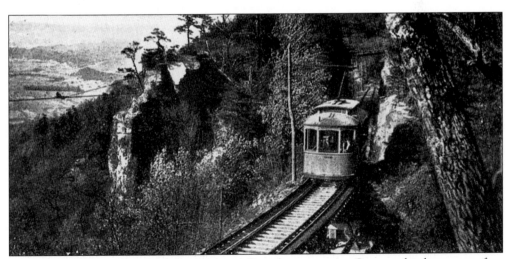

A car bound for Lookout Mountain is ascending the mountain. Cars on this line were often referred to as the "Surface Car." The view of Lookout Valley from the Surface Car line must have been impressive to the tourists bound for the mountaintop hotels. (From the author's collection.)

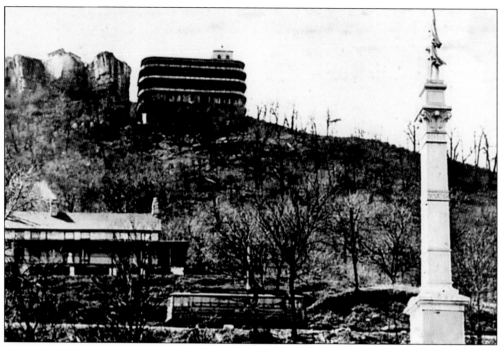

A Lookout Mountain–bound surface car is passing the Craven's House site, the Point Hotel, and one of the state monuments in the Chickamauga and Chattanooga National Military Park. By the time this photograph was taken in 1913, the Point Hotel had been abandoned. (Courtesy David H. Steinberg.)

This 1970s view shows one of the Southern Coach Company–built Incline cars passing the halfway station. It was replaced in 1986 when two new cars were placed in service. One of the replaced cars was retained by the Chattanooga Area Regional Transit Authority and the other was donated to the Tennessee Valley Railroad Museum. (Courtesy David H. Steinberg.)

# Six

# HISTORIC RAILROAD PRESERVATION

## THE TENNESSEE VALLEY RAILROAD MUSEUM AND THE CHATTANOOGA CHOO CHOO

With the development of improved highways and increasing use of personal automobiles and airplanes for travel, the end of the long-distance passenger train was near. However, there were many railroad employees and rail enthusiasts who wanted to ensure that something of the Golden Age of Railroading was preserved. The ranks of these employees and enthusiasts included two Chattanoogans, Paul H. Merriman and Robert M. Soule, who organized a group of area railroad enthusiasts to form the Tennessee Valley Chapter of the National Railroad Historical Society in 1961. The chapter began collecting railroad-related items and rolling stock. The intention was to create some sort of museum that would interpret railroad history, yet allow the visitor the chance to experience rail travel as it would have been like in the period between 1920 and 1950, the Golden Age of Railroading in America. Over the next 20 years, this organization evolved into the present-day Tennessee Valley Railroad Museum.

In 1971, the fledgling railroad museum found a home in East Chattanooga, using land donated by Southern Railway for a yard and station. Part of the property included the old East Tennessee and Georgia Railroad main line, which had been abandoned in 1954, following the opening of the new Citico Yard. During the reconstruction of Citico Yard, a new section of main line was built around the north end of Missionary Ridge, bypassing Whiteside Tunnel. The remainder of the old main line, consisting of 1.5 miles of trackage connecting to the new Southern Railway main line at Jersey, Tennessee, was offered to the museum on the condition that they replace the missing viaduct at Tunnel Boulevard. In November 1977, a new bridge was opened at Tunnel Boulevard and the remaining portion of the line was slowly rebuilt. Land adjacent to the railroad line at Jersey was acquired and developed as the main passenger station of the new museum. Construction of the station at East Chattanooga and mechanical shops was completed in 1982. In time, the railroad museum and its operating department, the Tennessee Valley Railroad, transformed from a weekend operation run by a group of hobbyists to one of the largest railroad operators of its type in North America.

At very much the same time as the railroad museum was becoming established, two important stories with very different outcomes were playing out downtown. In September 1972, the State of Georgia announced that it was offering for sale its share of Union Depot. This share went to the Stone Fort Land Company on October 31, 1972, for a bid of $445,000. Shortly thereafter, the Stone Fort Land Company and the Louisville and Nashville Railroad announced that Union Depot would be demolished, allowing the 20-acre site to be commercially

redeveloped. There was significant protest by citizens and local historical organizations who pointed to the building's significant place in Chattanooga's history and the fact that it was placed on the National Register of Historical Places. However, no amount of pressure could convince the State of Georgia to reconsider its actions and the sale of the state's portion of the depot was given final approval on March 21, 1973. The depot and the historic pre–Civil War Car Shed were demolished a short time later.

At the same time, the future of the Southern Railway's once-grand Terminal Station was being determined by a small group of Chattanooga businessmen who had grand plans for the former train station. Their vision involved transforming the former rail terminal into a family resort complex with a hotel, shops, and restaurants designed around the theme of the Glenn Miller song "Chattanooga Choo Choo." The plans of this group, headed by local businessman B. Allen Casey Jr., were announced on April 30, 1972, and work on the conversion were begun immediately as the facility was to open in less than 12 months. In keeping with the theme of Glenn Miller's song, the resort and its parent company would be named the Chattanooga Choo Choo. Thus, while the Union Depot succumbed to the wrecker's ball, more than $4 million was being spent to complete the conversion of Terminal Station into a resort complex. The Chattanooga Choo Choo opened to the public on April 11, 1973. The new facility offered the visitor hotel, shopping, and dining all in one unique facility. Railroad passenger coaches located by the platforms had been rebuilt into deluxe hotel rooms. New Orleans Public Service Car No. 952, which once plied the Canal Street line, was used to offer hotel guests transportation around the resort property. Originally one of two New Orleans Public Service streetcars transferred to the Tennessee Valley Railroad Museum, Car No. 952 was later sold to the Chattanooga Choo Choo. The Chattanooga Choo Choo complex has enjoyed success from the start and has hosted many important functions. In March 1980, the Choo Choo complex helped to commemorate the centennial anniversary of the completion of the Cincinnati Southern Railroad, and in 1986, it hosted the Tennessee Homecoming Special, which brought then Gov. Lamar Alexander to town. The Choo Choo has also hosted other passenger excursion trains on occasion, in addition to seasonal passenger train operations operated by the Tennessee Valley Railroad. With the success attained by both the Tennessee Valley Railroad Museum and the Chattanooga Choo Choo, it seems highly unlikely that the historical connection between Chattanooga and her railroad past will ever be forgotten.

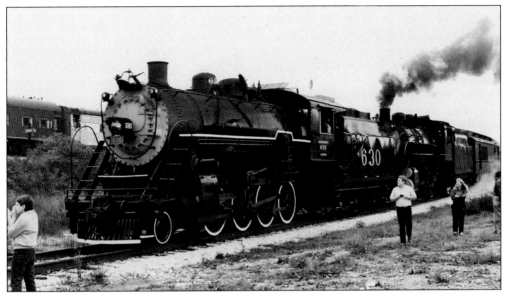

Extra 630 West has just turned on the wye at Grand Junction and is preparing for the return trip to East Chattanooga as a Southern Railway excursion train passes on the main line in the background in this 1984 scene. Southern Railway No. 630 is a Ks-class locomotive built in 1904 by the American Locomotive Company at Richmond, Virginia. Now owned by Tennessee Valley Railroad Museum, the locomotive is undergoing a restoration by the museum in preparation for its return to service. (Courtesy Steven R. Freer.)

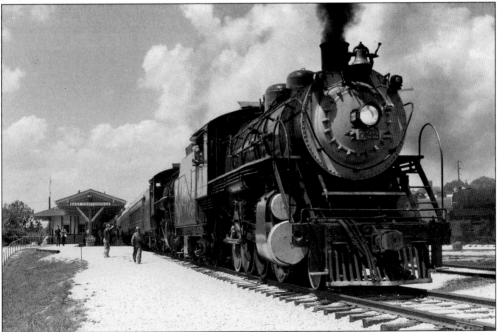

In the early days at the Tennessee Valley Railroad Museum, double-headed passenger trains were not uncommon. Here Southern Railway Ks-class No. 722 has arrived at East Chattanooga with the local passenger train. The present depot was built in 1980 and is located 150 feet west of the original East Chattanooga/Sherman Heights station. (Courtesy Steven R. Freer.)

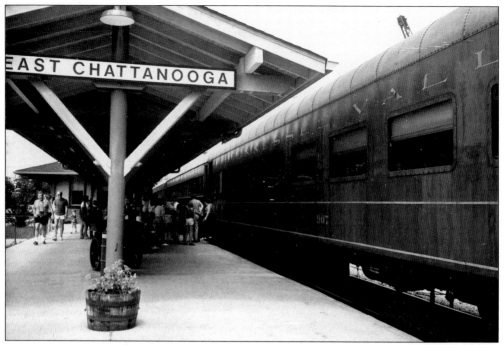

On September 1, 1985, another trainload of happy passengers is seen detraining at East Chattanooga. There the locomotive will be turned for the return trip to Grand Junction. The depot at East Chattanooga was built by the railroad museum in 1980. (Courtesy Tennessee Valley Railroad Museum.)

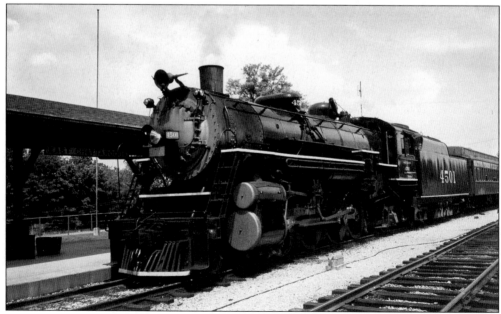

The Tennessee Valley Railroad No. 4501 is arriving with a local train on the afternoon of April 25, 1997. This locomotive was the first piece of rolling stock to be acquired by the museum and was for many years the grand old lady of the Southern Railway's Steam Excursion Program. (From the author's collection.)

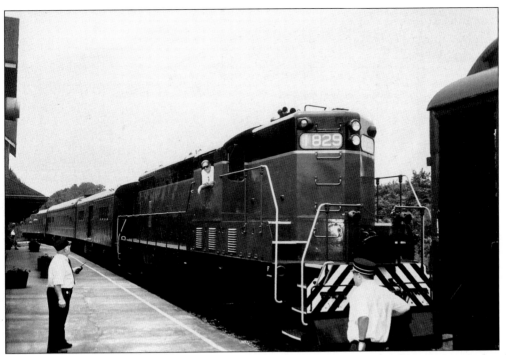

It's train time at Grand Junction on a warm summer afternoon. Here the Downtown Arrow has just arrived from the Terminal Station downtown and has pulled in behind the local train. Soon the local train will depart for East Chattanooga. (From the author's collection.)

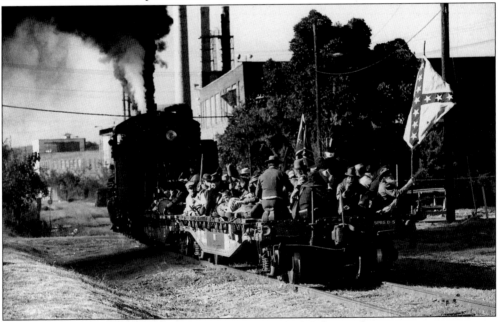

While the railroad receives many requests for non-scheduled special trains, some are stranger than others. On this summer day in 1999, locomotive No. 610 is seen leaving Rossville, Georgia eastbound to La Fayette, Georgia towing two flatcars of Confederate re-enactors to a mock engagement near La Fayette. (Courtesy Steven R. Freer.)

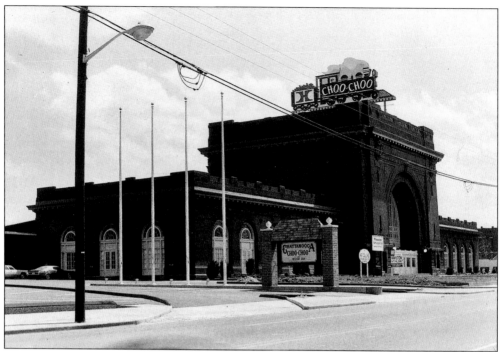

In April 1972 the Chattanooga Choo Choo Company was created to preserve the former Southern Railway Terminal Station by developing it into a successful business venture. Here we see the building in its final stages of redevelopment. (Courtesy David H. Steinberg.)

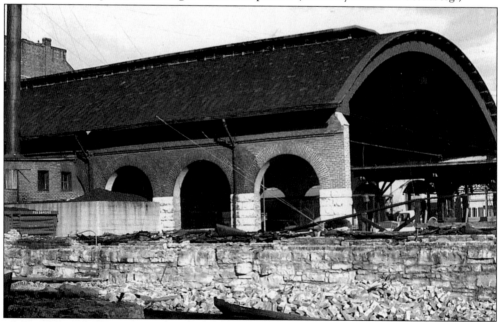

The end has come for Union Depot in 1972. By the time this photograph was taken, the Western and Atlantic freight depot had been demolished and the Car Shed found itself in the sights of the wrecking ball. One of the few items saved was the cornerstone of the Car Shed, which found its way to the Tennessee Valley Railroad Museum. (Courtesy David H. Steinberg.)

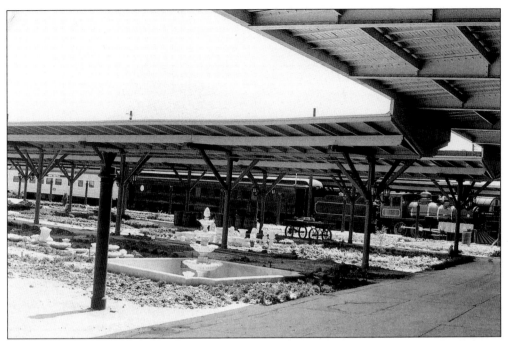

This view of the Terminal Station complex in early 1972 shows the installation of flowerbeds and rolling stock in the platform area. The locomotive seen is the former Smokey Mountain Railroad No. 206. (Courtesy David H. Steinberg.)

One of the attractions offered by the Chattanooga Choo Choo was a trolley ride around the complex. One of the cars used was No. 952, originally built by the Perley Thomas Car Company of High Point, North Carolina, for the Canal Street line operated by New Orleans Public Service, Inc. until May 1964. (Courtesy Tennessee Valley Railroad Museum.)

Seen on May 20, 1986, the *Tennessee Homecoming Special* is backing into the Chattanooga Choo Choo. Here, a set of Southern Railway FP-7s with a set of *Homecoming Special* flags and headboard is backing the train around the wye at CT Tower. (Courtesy Steven R. Freer.)

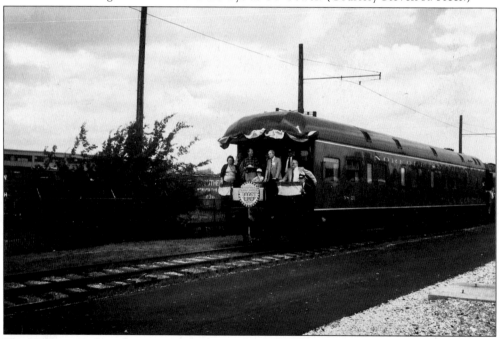

The *Homecoming Special* is seen as it backs into the Chattanooga Choo Choo. The most notable VIP standing on the observation platform of Norfolk Southern Business Car No. 21 is then Gov. Lamar Alexander, standing third from the left wearing his trademark plaid shirt. (Courtesy Tennessee Valley Railroad Museum.)